IT'S
NOTHING,
SERIOUSLY

JOHN McGREAL

Matador
9 Priory Business Park,
Wistow Road, Kibworth Beauchamp,
Leicestershire. LE8 0RX
Tel: 0116 279 2299
Email: books@troubador.co.uk
Web: www.troubador.co.uk/matador
Twitter: @matadorbooks

ISBN 978 1785892 219

British Library Cataloguing in Publication Data.
A catalogue record for this book is available from the British Library.

Printed and bound in the UK by TJ International, Padstow, Cornwall

Matador is an imprint of Troubador Publishing Ltd

Also in this series:

CONTENTS

Preface

I am glad now to publish *It's Nothing, Seriously*, conjointly with *It's Absence, Presently* and *It's Silence, Soundly*. All three of these artist's books present a new aesthetic object: The Bibilograph. They constitute together a decentred trilogy united in their concept, each representing a stage in the development of the Bibliograph. Work on *It's Silence, Soundly* began in late April this year and has continued simultaneously with writing the other books. Starting with any one text the reader is minded at once to reflect on the wider scene of reading; from the first to go beyond its immediate sphere to that of another. The trilogy is written for a curious reader still open to the unknown with a desire to explore further - absence and silence as well as nothing/ness in *terra incognita*.

The trilogy of artist's books introduced here represents another stage in my work on the dialectic of mark, word and image. In the short term they emerged out of some artwork on punctuation last year. On completing a print called <u>mu (sic)</u> (210x297mm) I had written, 'Mute graphic elements depict volumes of silent sound in the emptiness of the space of writing' (*The Point of It*: 2015: 415). After finishing the piece I had tried but failed to start writing another narrative piece in monosyllables. Coming up 'with nothing' by March then became an unexpected spur to begin in a new form the artist's book now called '*It's Nothing, Seriously*', closely followed in April by *It's Absence, Presently* and in May by the present work. *It's Silence, Soundly*.

In the longer term these new works incorporating the Biblograph emerged as a break with the form of my earlier 2D prints based on punctuation. In 2003 John Lennard's 'new theory of punctuation on historical principles' [*Ma(r)king The Text*, Eds J. Bray et al, Ashagate: 2000: 5-6] had helped to open up a new conceptual space for my visual artwork. The theory redefined punctuation, extending it to 'the way in which letters punctuate the whiteness of the page'. The general idea included everything graphically from 'letter-forms punctuating the blank page' to 'the book itself as a complete object, punctuation space'. In 2003 this conception had facilitated prints like <u>Bibliographical Space</u> (150x60cm) (*The Point of It*, 2015: 429).

As a new aesthetic object in the codex format of artist's books like *It's Nothingy, Seriously* the Bibliograph constitutes a further stage exploring the visual problematic of punctuation thus opened up. In both form and content the Bibliograph transcends the narrow limits of the academic Bibliography.

The viewer is thus asked both to consider the spacial disposition of the Bibliograph within the trilogy of artist's books as a whole and to compare and contrast its location in the overall composition of each work. The perceptive reader will note both the varying strategic placements and sizes of the respective Bibliographs in each of the different texts. In contrast to the relatively delimited versions of the Bibliograph contained in *It's Nothing, Seriously* (as well as in *It's Absence, Presently*), the Bibliograph achieves its most developed artistic form in *It's Silence, Soundly*, occupying the whole space of the text. Paradoxically once again to start with nothing led to everything! In respect of its spacial placement in this particular book, *It's Nothing, Seriously*, I am especially grateful to Lawrence Sterne as for his extra-ordinary conceptual plenitude and pioneering representation of nothing in Chapter XXIV of Volume IV of *The Life & Opinions of Tristram Shandy, Gentleman* (2003).

At the same time, notwithstanding the aesthetic differences in the placement of the Bibliograph in each artist's book, the reader may wish to reflect on their similar internal tripartite formations. In particular the reader's attention is also drawn specifically to the pagination of these works, as well as to the fact that formally the various artist's books have an identical overall length, which emphasizes their shared inter-textual relation. Among others D.E. Mackenzie has noted some important examples in early Modernist Literature of the conceptual importance of a book's length (*Bibliography & The Sociology of Texts*, CUP, 1999: 57-60).

No more a bibliography than an archive or an anthology, the Bibliograph in these artist's book is characterised hermeneutically by (1) the dominance of a thematic motif in each entry - in this work, *Nothing/ness* (2) repetition of the same dominant thematic motif in each entry. At times the rhythm of repeating both the dominant and subsidiary elements in typing out entries on the computer keyboard surprisingly lent it an almost musical quality of composition.

Every Bibliograph is marked too by the order of presentation of its entries. Like that of academic bibliographies this regularity is governed overall by the logical sequence of the alphabet but its order is structured on grounds of aesthetic preference not academic convention. The strategic point of immediate entry in the circle of the alphabetic sequence is constitutive. To start this Bibliograph with an article by J.J. Webster, *It's Nothing To Laugh At* is at once ironically both to affirm and to deny nothing in the formulation of the questions posed, as well as emphatically to situate the text within the 'It series' of artist's books as a whole. After an earlier humorous effort to develop a comprehensive non-sense 'theory of everything' in *The Book of It* (2010), this further attempt at a form that also represents anything and something hopefully equally succeeds itself in the impossible endeavour to embrace everything – seriously!

The reader is also asked to consider the order of presentation of the details of each entry in the Bibliograph, similarly arranged on artistic not scholarly grounds. In these conventional references transformed, The Names of Author, Text, Publisher; The Type of Text (Books/Articles/Scores/Conference Papers); Issue; Page Numbers; Year, etc) are set out and shaped on the page according to the aesthetic requirement. In Constructivist fashion italics, boldface, underlining, etc as well as spacing is used for clarity and emphasis. The graphic presentation of entries on the page is equally a display of their sometimes humorous as well as serious conceptual content.

Moreover from the opening entry of a Bibliograph the reader is asked to go beyond the immediate given to other entries – and so to read in a new way. In virtually Surrealist fashion the reader is confronted by entries from various unfamiliar disciplines brought together in aleatory fashion by the nominal but contingent sequence of the alphabet. In the play of similarity and difference within a heterogeneous domain, no entry exists alone but only in relation to others, in a complex interactive network of connections across the conventional limits of disciplines in a range of the arts and sciences. Occupying a site of word and image, artist's books such as these that also contain a range of many textual references to both are a particularly suitable form in which to explore the relations between the conventionally separated domains of visual art and literature in western bourgeois culture.

Further, given the details of the initial entry in a Bibliograph - to find the text of a whole article, book or score the reader has the choice whether or not to follow it up via a library catalogue or the Internet. The research for these Bibliographs was only possible through the electronic transmission of resources now available on the Web. The reader is asked to read a text entry in these artist's books not only in linear and spacial but also in premeditated terms: initially in this open process to do a guilty 'pre-reading' in order to read further elsewhere. With an act of deliberate premeditation the immediate book has to be relinquished and its 're-reading' deferred.

The reader is thus reminded once more that as an aesthetic object the Bibliograph is also an object of knowledge. As such its selected material is equally imaginative and informative, the recurrence of its dominant element allowing investigation of its content in depth. Every disparate textual entry is a variation on a common theme, its singularity and complexity a unique, random context for each chance repetition of the dominant motif in which its meaning(s) is/are determined and reproduced under determinate conditions. The considerable range of the literature contained in these initial Bibliographs clearly brings out the differentiated physical, psychical and social complexity of what Jerome McGann has called 'the textual field' (*The Textual Condition*, Princeton, 1991:125).

Even a cursory glance at the Bibliograph on Nothing highlights the amusing paradox that so much continues to be written about it across the range of arts and sciences – seriously. In philosophy it shows the diversity of on-going epistemological and ontological debates about nothing/ness, as well as empirical questions about its materiality in the organic and inorganic sciences. In psychology it reveals a variety of psychoanalytic papers exploring the causes & effects of psychical feelings and states of nothing/ness in the conscious and unconscious formation of the self. In social terms it highlights some of the mechanisms producing inequality under global capitalism leaving oppressed classes and minorities with virtually nothing in respect of power and control over their own lives. Textually the 'shifting centre' of each Bibliograph hence contains the imperative to combine the 'radial reading' suggested by Jerome McGann with a premeditated, differential one 'on historical principles' which admits of layered space and time at all levels of reproduction.

J. MGreal
December 2015

BIBLIOGRAPH

(A) BOOKS

Webster, J.J.
It's Nothing To Laugh At
Stockwell, Ilfracombe UK 1973

Wee, G. *Nothing Grows Without The Rain*
Rhino Press, Downpatrick Ireland 1996

Weigt, B. *The Abundance of Nothing: Poems*
Northwestern University Press, US 2012

Weldon, F.
*Nothing To Wear and Nowhere to Hide
– A Collection of Short Stories*
Flamingo/Harper Collins London 2012

West, M. *Goodness Has Nothing To Do With It:
The Autobiography of Mae West*
Prentice-Hall, New York 1960

Weyermann, D.
*Answer Them Nothing – Bringing Down
The Polygamous Empire of Warren Jeffs*
Chicago Review Press, US 2011

Whedon, J.
Much Ado About Nothing *– A Film by
Joss Whedon Based On The Play by
WilliamShakespeare*
Titan Books, London 2013

Wickenden, D.
*Nothing Daunted: The Unexpected
Education of Two Society Girls in The West*
Simon & Schuster, New York 2011

Wigfall, C.
The Loudest Sound & Nothing
Faber & Faber, London 2007

Wilde, O. *Nothing... Except My Genius!*
The Wit &Wisdom of Oscar Wilde
Penguin, London 2010

The Critic As Artist – Some Remarks Upon
The Importance of Doing Nothing
Green Integer, Los Angeles US 1997

Wilder-Smith, A.E.
The Natural Sciences Know Nothing
Of Evolution
Master Books, San Diego Cal. US 1982

Williams, C. *Nothing In Her Way/River Girl*
Stark House Press, Eureka California 2014

Willis, C. *To Say Nothing of the Dog*
Orion, London 2013

Winkler, J.J. & Zeitlin, F.S.
Nothing To Do With Dionysos?
Athenian Drama In Its Social Context
Princeton University Press, USA 1992

Wippel, J.F. (Ed)
The Ultimate Why Question:
Why Is There Anything At All
Rather Than Nothing Whatsoever?
Catholic University of America Press,
Washington DC, USA 2011

Wodehouse, P.G.
Money For Nothing
Arrow Books, London 2008

Nothing Serious
The Overlook Press, NY 2008

Wolgroch, D. *Creation Out of Nothingness:*
Creatio Ex Nihilo
Lulu Enterprises 2007

Woods, G.
> *May I Say Nothing*
> Carcanet, Manchester 1998

Wren, M.K.
> *Nothing Is Certain But Death*
> Hale, London 1978

Wright, L.A.
> *Nothing In The World But Youth*
> Turner Contemporary, Margate UK 2011

Wurmser, L. & Jarass, H.
> *Nothing Good Is Allowed To Stand:*
> *An Integrative View of The Negative*
> *Therapeutic Reaction*
> Routledge, London 2013

Yeats, W.B.
> *Where There is Nothing:*
> *Plays for an Irish Theatre, Vol.1*
> A.H. Bullen London 1903

Young, A. *Something - Almost Nothing*
> Elizabeth Simon Press, Aberdeen 2011

> *The Enormous Logic of Nothing*
> Elizabeth Simon Press, Aberdeen 2014

Ypma, H. *Amazing Places Cost Nothing:*
> *The New Golden Age of Authentic Travel*
> Thames & Hudson, London 2013

Yu, C. *Nothing To Admire:*
> *The Politics of Poetic Satire*
> *From Dryden to Merrill*
> Oxford University Press, UK 2003

Ziegesar, C.V.
> *Nothing Can Keep Us Together*
> Bloomsbury, London 2005

Ziegler, R. *The Nothing Machine:*
 The Fiction of Octave Mirbeau
 AMS, New York 2010

Ziman, J.M. *Knowing Everything About Nothing:*
 Specialisation & Change
 In Scientific Careers
 Cambridge University Press, UK 1987

Zimmerman, B.E.
 Why Nothing can Travel Faster than Light
 Cassell, London 1996

Zizek, S. *Less Than Nothing: Hegel &*
 The Shadowof Dialectical Materialism
 Verso, London 2013

Acker, K. *Algeria: A Series of Invocations Because*
 Nothing Else Works
 Aloes Books, London 1984

Adler, E. *All or Nothing*
 Charnwood, Leicester 2011

Agar, K. *Nothing Solemn:*
 An Anthology of Comic Verse
 Zebra, Cambridge UK 1973

Agee, C. *Next to Nothing*
 Salt Publishing, Cambridge UK 2008

Alger, H. & Chandler, T.
 Nothing To Eat
 Barnes & Noble, New York 2012

Allen, R.G. *Nothing Down: How To Buy Real Estate*
 With Little Or No Money
 Simon & Schuster, London 1980

 Nothing Down For The 2000's: Dynamic
 New Wealth Strategies in Real Estate
 Free Press, London 2004

Ambrose, S.E.
> *Nothing Like It In The World: The Men*
> *Who Built The Railway That United America*
> Pocket Books, New York 2005

Amiry, S. *Nothing To Lose But Your Life:*
> *An 18 hour Journey with Marad*
> Bloomsbury Qatar Foundation, Deha 2010

Anderson, C.
> *Free: How Today's Smartest Businesses*
> *Profit By Giving Something For Nothing*
> Random House London 2010

Anderson, M.T.
> *The Astonishing Life of Octavia Nothing -*
> *Traitor To The Nation*
> Candlewick Press, Somerville USA 2006

Andersson, D.
> *The Nothing That Is:*
> *The Structure of Consciousness*
> *In The Poetry of WallaceStevens*
> Upsala Universitet, Sweden 2006

Andrews, E.H.
> *From Nothing To Nature – A Basic Guide*
> *To Evolution & Creation*
> EP Books, Darlington UK 1993

Angelou, M.
> *Wouldn't Take Nothing For My Journey*
> Virago, London 1995

Armeleder, J. M.
> *About Nothing:*
> *Arbeiten auf papier 1964-2004*
> JRP/Ringier, Zurich 2005

Arvo, P.D. *Balancing Oneness, Nothingness & Ego*
> *In One Hour*
> Create Space 2014

Ashley, T. *Sweet Nothings*
 Avon, London 2006

Austerlitz, S. *Money For Nothing:*
 A History of The Music Video
 From The Beatles to The White Stripes
 Continuum Publishing, London 2008

Avedon, R. *Nothing Personal:*
 Photographs by RichardAvedon
 & Text by James Baldwin
 Penguin, Harmondsworth 1964

Aynsley, B.W. *Nothing Like Steam:*
 Footplate Work On Southern Region
 Bradford Barton, UK 1980

Azzouni, J. *Talking About Nothing:*
 Numbers, Hallucinations and Fictions
 Oxford University Press, UK 2010

Bagnall, D. *Nothing Like Lauren Bacall*
 OCLC, 1999

Baird, J. *Nothing Changes Love*
 Mills & Boon, London 2012

Bakker, R.S. *The Darkness That Comes Before –*
 The Prince of Nothing: Book 1
 Orbit, London 2005

 The Warrior Prophet –
 The Prince of Nothing: Book 2
 Orbit, London 2006

 The Thousandfold Thought –
 The Prince ofNothing: Book 3
 Orbit, London 2007

Ball, R. *Low Tech:*
 Fast Furniture For Next To Nothing
 Century, London 1982

Bandera, M.C. & Miracco, R.
　　　　Morandi 1890-1964:
　　　　"Nothing Is MoreAbstract Than Reality"
　　　　Skira, New York 2008

Barnes, J.　*Nothing To Be Frightened Of*
　　　　Vintage Books, London 2009

Barnum, P.T. & Cook, J.W.
　　　　The Colossal P.T. Barnum Reader –
　　　　NothingElse Like It in The WholeUniverse
　　　　University of Illinois Press, USA 2005

Barrett, P.　*Law Of The Jungle: The 19$ Billion Legal*
　　　　Battle Over Oil in The Rain Forest &The
　　　　Lawyer Who'd Stop At Nothing To Win
　　　　Crown Publishers, New York 2014

Barringer, D.
　　　　There's Nothing Funny About Design
　　　　Princeton Architectural, New York 2009

Barrow, J.D.
　　　　The Book of Nothing: Vacuums, Voids
　　　　& The Latest Ideas About The Origin
　　　　Of The Universe
　　　　Vintage Books, London 2002

Bate, J. (Ed)
　　　　Much Ado About Nothing
　　　　(The RSCShakespeare)
　　　　Random House, London 2009

Baur, M, & Baur, S.
　　　　The Beatles and Philosophy:
　　　　Nothing You Can Think That Can't Be Thunk
　　　　Open Court, Chicago 2006

Bazelon, D.T.
　　　　Nothing But A Fine Tooth Comb:
　　　　Essays In Social Criticism, 1944-1969
　　　　Simon & Schuster, New York 1970

Beck, C.J. & Smith, S.
 Nothing Special: Living Zen
 Harper Collins, New York 1993

Beckett, S. *Texts for Nothing and Other Shorter Prose,*
 1950-1976
 Faber & Faber, London 2010

Bellinger, K. *Nothing New Under The Sun*
 Amarna, Sheffield UK 2005

Belloc, H. *On Nothing and Kindred Subjects*
 Dodo Press, Gloucester UK 2007

Beresford, P. *Names of Nothing:*
 An Exploration in Enclosed Space
 Logaston Press, Almely UK 2001

Berg, S. *Nothing In The Word:*
 Versions of Aztec Poetry
 JA/Grossman, Mushinsha Books, 1972

Bervin, J. & Werner, M.
 The Gorgeous Nothings:
 Emily Dickinson's Envelope Poems
 Granary Books, New York 2013

Betteridge, D. *Nothing Lost: (To Be Cont'd Tale)*
 Rhizone Press, Glasgow 2009

Betts, B. *When Nothing Goes Right*
 Ronald, UK 1989

Bigelow, H.P. *David Park, Painter: Nothing Held Back*
 Hudson Hills, New York 2009

Billmann, P, &Higgins, C.
 Foo Fighters: There Is Nothing Left ToLose
 Paperback 2000

Birjépatil, J. *Nothing Beside Remains*
 Fomite Press, Chicago 2015

Bjorklund, D.
> *Seinfeld Trivia: Everything about Nothing*
> Maizeland, Colorado USA 2013

Blair, R. *Nothing to Lose, Everything to Gain:*
> *How I Went from Gang Member to*
> *Multimillionaire Entrepreneur*
> Penguin Books, New York 2013

Blessed, B. *Nothing's Impossible*
> Simon & Schuster, London 1994

Blum, J.D. & Smith, J.E.
> *Nothing Left To Lose: Studies of Street People*
> Beacon Press, Boston 1972

Borges, J.L.
> *Everything and Nothing*
> New Directions, New York 2010

Boston, L.M.
> *Nothing Said*
> Houghton Miffin Harcourt, Dublin 1971

Bourgeois, L.
> *Nothing to Remember*
> Rowman & Littlefield, Oxford UK 2002

Bowles, P. *Next To Nothing – Collected Poems*
> Sphere, London 1986

Brice, C. *Age Ain't Nothing But A Number:*
> *Black Women Explore Midlife*
> Souvenir Press, London 2005

Brodribb, S.
> *Nothing Mat(t)ers:*
> *A Feminist Critique Of Postmodernism*
> Spinifex, Melbourne, Australia 2003

Brooke, L. *Chestnut Hill – All or Nothing*
> Scholastic Inc, London 2012

Brown, D. & Thomas, B.
 Generation Empty
 Five Dimensions of Nothingness
 Create Space 2005

Brown, E, *Nothing Ever Happens in North Berwick:*
 The Somali Pirate Adventure
 Malcolm Mitchell UK 2014

Brownlow, M. *The Big White Book With Almost Nothing*
 Ragged Bears, Andover UK 2000

Brunn, E.Z. *St Augustine:*
 Being & Nothingness
 Paragon House, New York 1986

Buckley, C. *On The Poetry of Philip Levine:*
 Stranger To Nothing
 Ann Arbor, Michigan 1991

Buckner, C. *Apropos of Nothing: Deconstruction,*
 Psychoanalysis & The Coen Brothers
 State University of New York Press,
 Albany US 2014

Burgess, A. *Nothing Like the Sun*
 Norton, London 1996

Burningham, H. *Much Ado About Nothing - Retold by*
 HilaryBurningham
 Evans Bros, London 2005

Burns, P. *Nothing Ever Stays The Same*
 Lion, Tring UK 1987

Burton, J. *Nothing Personal*
 Samhain Publishing, Macon US 2008

Burton, L. *Nothing's Sweeter Than Candy*
 Avon, Massachusetts, US 2015

Butler, B. *Nothing – A Portrait of Insomnia*
 Harper, London 2011

Butler, W.F.
>*F. D. Roosevelt: Nothing To Fear But Fear*
>Hodder & Stoughton, London 1982

Cadden, J. *Nothing Natural Is Shameful:*
>*Sodomy & Science*
>*In Late Medieval Europe*
>University of Pennsylvania Press, US 2013

Callahan, J.R.
>*The Nothing Hot Delay Problem in The*
>*Production of Steel*
>Toronto, 1971

Cao, N. *There's Nothing I Can Do When I Think*
>*Of You Late At Night*
>Columbia University Press, N. York 2009

Carbin, D. *Thanks For Nothing*
>Black Swan, London 2008

Carter, A. *Nothing Sacred: Selected Writings*
>Virago, London 1982

Carter, J. *Nothing To Spare:*
>*Recollections*
>*Of Australian Pioneering Women*
>Penguin, Harmondsworth UK

Carter, R. *Certain of Nothing*
>Mills & Boon, London 1992

Carter, R.E.
>*The Nothingness Beyond God:*
>*An Introduction To The Philosophy*
>*Of Nishida Kitaro*
>Paragon House, St Paul Minneapolis 1997

Caselli, D. (Ed)
>*Beckett and Nothing:*
>*Trying To UnderstandBeckett*
>Manchester University Press, UK 2012

Casey, N.J. & Renshaw, A.J.
 The Lash:
 Nothing Matters More Than The Game
 Wolfridge London 2008

Cassidy, J. *Between Eternity & Nothingness*
 A.H. Stockwell, Ilfracombe 1961

Castro, F. *Nothing Can Stop The Course Of History*
 Pathfinder, London 1986

Catalano, J.S. *A Commentary on Jean-Paul Sartre's,*
 "Being & Nothingness"
 Harper & Row, New York/London 1974

Chapman, D. *They Teach Us Nothing*
 White Cube, London 2011

Charleston, D. *Nothing Better To Do*
 Jardine, Lower Raydon Suffolk UK 1999

Child, L. *Nothing To Lose*
 Bantam Books London 2009

Childish, B. *Poems Without Rhyme, Without Reason,*
 Without Spelling, Without Words,
 Without Nothing
 Rochester, Kent/Black Hand Distn 1985

Choyce, L. *The Republic of Nothing*
 Goose Lane Edns, New Brunswick
 Canada 2007

Christian, D, & Brown, C. & Benjamin, C.
 Big History:
 Between Nothing &Everything
 McGraw-Hill New York 2013

Christie-Renaud, R.
 A Slow Slide Into Nothing: A Mother
 Daughter Journey Through Dementia
 Create Space UK 2014

Claessen, G.
> *Poems About Nothing*
> Stockwell, Ilfracombe UK 1981

Clamp, M. *Much Ado About Nothing*
> *Cambridge Student Guide*
> Cambridge University Press, London 2002

Clancy, S. *Thanks For Nothing, Hippies*
> Salmon Poetry, Cliffs of Moher,
> Co Clare, Eire 2012

Clarke, D. *All or Nothing At All:*
> *A Biography of Frank Sinatra*
> Fromm International, Mt Prospect US 1997

Clarke, N. *Nothing But Trouble*
> Andersen, London 1997

Close, F. *Nothing:*
> *A Very Short Introduction*
> Oxford Publications, 2009

Cobain, B. *When Nothing Matters Anymore*
> *A Survival Guide for Depressed Teens*
> Free Spirit Publishing, Minneapolis 2009

Coggins, G.
> *Could There Have Been Nothing?*
> *Against Metaphysical Nihilism*
> Palgrave Macmillan, London 2010

Cohen, A. *Nothing To Fear: FDR's Inner Circle &*
> *TheHundred Days That Created Modern*
> *America*
> Penguin, New York 2010

Cohen, C.D.
> *The Seuss, The Whole Seuss & Nothing*
> *But The Seuss – A Visual Biography of*
> *Theodor Seuss Geisel*
> Random House, New York 2004

Cohn, L. *Nothing But The Blues:*
 The Music &The Musicians
 Abbeville Press, New York 1999

Cohn, W. *Nothing But Grass*
 Fourth Estate, London 2014

Cole, H. *Nothing to Declare: Poems*
 Macmillan, NY 2015

Collister, T. *Nothing On Tonight*
 New Playwright's Network, 1991

Comaskey, B. *The Team: An Explosive Novel Set In*
 A Rural Irish Village Where Nothing
 Mattered More Than The Hurling Team
 Deel Pubns, Ireland 2015

Conway, D.W. *The World As Will To Power - Nothing Else?*
 Metaphysics and Epistemology
 Routledge, London 1998

Cookson, L.& Loughrey, B. (Eds.)
 Critical Essays: **Much Ado About Nothing**
 Longman, Harlow 1989

Cooper, L. *It Was Nothing!*
 Author House, Bloomington US 2013

Cope-Williams, M.J.
 Nothing Strange
 LRLB Publications, Brecon Wales 2006

Cottrell, S. *Do Nothing to Change Your Life:*
 Discovering What Happens When You Stop
 Church House Publishing,
 London 2007

 Do Nothing... Christmas Is Coming:
 An Advent Calendar With A Difference
 Church House Publishing,
 London 2009

Coupland, D.
　　　　　Marshall McLuhan – You Know Nothing
　　　　　Of My Work!
　　　　　Atlas, New York 2010

Cox, G.　　*How To Be A Philosopher, or, How To Be*
　　　　　Almost Certain That Nothing Is Certain
　　　　　Continuum, New York/London 2010

　　　　　The Existentialist Guide To Death, The
　　　　　Universe & Nothingness
　　　　　Continuum, New York/London 2012

Craig, G.　*Fit For Nothing? Young People, Benefits*
　　　　　& Youth Training
　　　　　Coalition of Young People & Social
　　　　　Security1991

Crawford, P.
　　　　　Nothing Purple, Nothing Black
　　　　　Book Guild, Lewes UK 2012

Critchley, S.
　　　　　The Hamlet Doctrine:
　　　　　Knowing Too Much,Doing Nothing
　　　　　Verso, London 2013

　　　　　Very Little... Almost Nothing!
　　　　　Death ,Philosophy &Literature
　　　　　Routledge, London 2004

Cunningham, C,
　　　　　Genealogy of Nihilism: Philosophies of
　　　　　Nothing & The Difference of Theology
　　　　　Routledge, London 2002

Cupitt, D.　*Creation Out Of Nothing*
　　　　　SCM Press, London 1989

Curtis, L.　*Nothing But The Same Old Story –*
　　　　　The Roots of Anti-Irish Racism
　　　　　Information on Ireland, Dublin 1984

Cutrofello, A.　　*All For Nothing – Hamlet's Negativity*
　　　　　　　　　The MIT Press, London 2014

D'Ancona, M.　　*Nothing To Fear*
　　　　　　　　　Hodder & Stoughton, London 2008

Davis, F.　　　　*Bebop & Nothingness:*
　　　　　　　　　Jazz & Pop At The End of The Century
　　　　　　　　　Prentice Hall, London 1998

Davis, W.R.　　　*Twentieth Century Interpretations of*
　　　　　　　　　Much Ado About Nothing
　　　　　　　　　A CollectionOf Critical Essays
　　　　　　　　　Prentice-Hall, Englewood Cliffs NJ 1969

D'Costa, G., Nesbitt, E., Pryce, M., Shelton, R. & Slee, N.
　　　　　　　　　Making Nothing Happen: Five Poets
　　　　　　　　　Explore Faith and Spirituality
　　　　　　　　　Ashgate, Farnham UK 2014

Dedopulos, T.　　*Something For Nothing On The Net*
　　　　　　　　　Carlton, London 2002

Dee, J.　　　　　*Thanks For Nothing*
　　　　　　　　　Doubleday, London 2009

Delgado, A.　　　*Nothing Up My Sleeve*
　　　　　　　　　Harrap, London 1966

Demick, B.　　　*Nothing to Envy: Real Lives in NorthKorea*
　　　　　　　　　Granta, London 2010

Deslé, R.　　　　*You Ain't Seen Nothing Yet*
　　　　　　　　　Lennoo, Tielt 2013

De Somogyi, N.　*Much Ado About Nothing=Much Adoe*
　　　　　　　　　About Nothing
　　　　　　　　　Nick Hern, London 2006

Dessau, J.　　　　*All or Nothing:*
　　　　　　　　　The Life of Anne Boleyn
　　　　　　　　　Ulverscroft, Leicester 1998

De Vigan, D.
 Nothing Holds Back The Night
 Bloomsbury, London 2014

Dewdney, A.K.
 200% Of Nothing: An Eye-Opening Tour
 Through The Twists & Turns Of Maths
 Abuse & Innumeracy
 Wiley, Chichester 1993

Dewey, J. *Beyond Grief and Nothing:*
 A Reading ofDon Del Lilo
 University of South Carolina Press,
 Columbia SC. USA 2006

Dickinson, P.
 A Box of Nothing
 Gollancz, London 1985

Dickshit, S.S.
 Journey Towards Nothingness:
 A Personal Quest
 Chetana, Mumbai 1995

Diehl, D. *Nothing Left Sacred*
 Celestial Press Ravenswood 2014

Diller, E. & Scofidio, R.
 Blur:
 The Making of Nothing
 Harry N. Abrams, London 2002

Diski, J. *Nothing Natural*
 Virago, London 1990

Doctor, G. & Oakley, M.
 Something For Nothing: Reinstating
 Conditionality For Jobseekers
 Policy Exchange, London 2011

Dolar, M. *A Voice And Nothing More*
 The MIT Press, London 2006

Dourley, J.　　　*Jung and The Mystical Experience of*
　　　　　　　　Nothingness: Religion and Psychological
　　　　　　　　Implications
　　　　　　　　The Guild of Pastoral Psychology,
　　　　　　　　London 2006

Dowley, J.P.　　*Jung & His Mystics:*
　　　　　　　　In The End It All Comes To Nothing
　　　　　　　　Routledge, London 2014

Doyle, E.　　　　*Nothing Green*
　　　　　　　　Magna, Long Preston UK 2004

Droit, R.-P.　　　*The Cult of Nothingness:*
　　　　　　　　The Philosophers& The Buddha
　　　　　　　　Chapel Hill: University North Carolina 2003

Dumas, M.　　　*Sweet Nothings: Notes and Texts*
　　　　　　　　1982-2014
　　　　　　　　Koenig Books, London 2014

Dunne, J.W.　　*Nothing Dies*
　　　　　　　　Faber & Faber, London 1940

Durrell, L.　　　*Nothing Is Lost, Sweet Self*
　　　　　　　　Poem byLawrence Durrell
　　　　　　　　Turret Books, London 1967

Duthie, J.　　　*Say Nothing:*
　　　　　　　　The Harrowing Truth
　　　　　　　　About Auntie's Children
　　　　　　　　Mainstream Publishing, Edinburgh 2012

Dutton, G.F.　　*Nothing So Simple As Climbing*
　　　　　　　　Diadem, London 1993

Dynamo*Nothing Is Impossible*
　　　　　　　　Ebury Press, London 2013

Edwards, B.H.　*Nothing But The Truth – The Inspiration,*
　　　　　　　　Authority & History of The BibleExplained
　　　　　　　　EP Books, Grand Rapids, US 2006

Ehman, K.

 Keep It Shut:
 What To Say, When To Say It,
 How To Say It, And When To Say
 Nothing At All
 Zondervan, Grand Rapids, US 2015

Ehn, B. & Lofgren, O.

 The Secret World of Doing Nothing
 University of California Press,
 Oakland 2010

Eichendorff, J.

 Memoirs of a Good-For-Nothing
 Calder & Boyars, London 1966

Ellegood, A.

 All This And Nothing
 University of California/Delmonico Books
 USA 2011

Ellis, H. *Much Ado, Mostly About Nothing*
 Methuen & Co Ltd, London 1934

Ellis, L. *Death Is Nothing At All*
 Palm Tree, Florida US 1991

Ellsworth, E.E.

 Neddy Knew Nothing
 Blackie, London 1968

Engvall, R.P.

 TheProfessionalization of Teaching:
 Is It Truly Much Ado About Nothing?
 University Press of America, USA 1997

Eno, W. *Thom Pain: (Based on Nothing)*
 Oberon Books, London 2004

Ephron, N.

 I Remember Nothing & Other Reflections
 Doubleday, London 2011

Epstein, M.W. &McCormick, E.W.
 Nothing To Lose: Psychotherapy,
 Buddhismand Living Life
 Continuum, London 2005

Evans, C. *Nothing To Pay*
 Cardinal, London 1990

Evans, M. *Nothing To Get Hung About:*
 A ShortHistoryOf The Beatles
 City of Liverpool Public Relations, 1975

Evans, M. *Signifying Nothing:Truth's True Contents*
 In Shakespeare's Text
 Harvester, Brighton 1986

Farshley, F. *Farm of Fear; Nothing In The Dark*
 Ladybird, London 2012

Federman, R. *Double or Nothing: A Real FictitiousDiscourse*
 Fiction Collective Two, Boulder, 2005

Fennell, A.H. *Whatever You Say, Say Nothing:*
 Why Seamus Heaney is No. 1.
 ELO Pubs, Dublin 1991

Ferran, B. Et al *Null Object:*
 Gustav Metzger Thinks AboutNothing
 Black Dog Books, London 2012

Fielding, J. *Nothing But Rich*
 Acorn, Newark 2003

Fielding, N. *On Nothing*
 University of Oxford, Text Archive

Fisher, D.E. *Much Ado About (Practically) Nothing:*
 A History of The Noble Gases
 Oxford University Press, UK 2010

Fleming, J. *Nothing Is The Number When You Die*
 The Murder Press, London 2013

114

Fletcher, P.
 Deeper Than Nothingness
 Lulu.Com 2008

Flinn, A. *Nothing To Lose*
 Harper Collins, London 2005

Foner, E. *Nothing But Freedom:*
 Emancipation
 & It's Legacy
 Louisiana State UP, US 1989

Ford, A. *Nothing So Strange:*
 The Autobiography Of Arthur Ford
 Harper, New York 1958

Forde, C. *Chamber of Nothing*
 Heinemann, Oxford UK 2011

Fortune, M.M.
 Is Nothing Sacred?
 When Sex Invades
 ThePastoral Relationship
 Harper & Row, New York 1992

Fox, N. *Love or Nothing*
 Mills & Boon, London 1993

Francis, C. *There is Nothing Like a Dane!*
 The Lighter Side of Hamlet
 Robson Books, London 2003

Francois, P. & Garcia, E.
 Interview & Interrogation Manual:
 NothingBut The Truth
 Third Degree Communications,
 San Jose, CA US 2014

Franczak, E.
 Against Nothingness
 Wydawnictwo Literackie,
 Cracow 1986

Franks, P.W. *All or Nothing: Systematicity,*
Transcendental Arguments, &
Skepticism in German Idealism
Harvard University Press, Mass. 2005

Friedman, A. *Nothing Sacred:*
A Conversation with Feminism
Oberon Press, Ottawa 1992

Friedman, M.S. *To Deny Our Nothingness:*
Contemporary Images of Man
Victor Gollancz, London 1967

Friedman, R.M. *And Nothing But The Truth*
George T. Bissel
Pennsylvania State University, 1995

Friedman, R.N. *Nothing*
Flux, UK 2008

Frondel, M. *Facing The Truth About Separability:*
Nothing Works Without Energy
University of Heidelberg, 2000

Gaitonde, M. *Nothing is Everything: The Quintessential*
Teachings of Sri Nisargadatha Maharaj
Zen Publications, Mumbai 2014

Galea, R. *Nothing in My Hand I Bring: Understanding*
The Differences Between Roman Catholic
& Protestant beliefs
Mathias Media, Sydney Australia 2007

Gall, C. *There's Nothing To Do On Mars*
Little, Brown & Co, New York 2008

Gardner, L. *Fear Nothing*
Headline, London 2014

Gardner, S. *Sartre's , **Being & Nothingness**:*
A Reader's Guide
Continuum, London 2009

Garner, J. *Busy Doing Nothing*
 Axis, Shrewsbury UK 2011

Garza, J. & Lupo, J.
 Nothing to Wear?: A Five-Step Cure
 For The Common Closet
 Penguin, New York 2006

Geare, M. & Holloway, D.
 'Nothing So Became Them_':
 Some Improved Obituaries
 Buchan & Enright, London 1986

Geftner, A.
 Trespassing on Einstein's Lawn: A Father,
 A Daughter, The Meaning of Nothing, &
 The Beginning of Everything
 Bantam Books, New York 2014

Geiger, J. *Nothing Is True – Everything's Permitted:*
 The Life of Brion Gysin
 Disinformation, New York, 2005

Genz, H. *Nothingness:*
 The Science of Empty Space
 Helix, Deddington 1999

George, A. (Ed.)
 I Am, Therefore I Think: Philosophers
 Answer Your Questions About Love,
 Nothingness & Everything Else
 Sceptre, London 2007

Gery, J. *Nuclear Annihilation & Contemporary*
 American Poetry: Ways of Nothingness
 University Press of Florida,
 Gainesville 1996

Giacardi, D.A.
 Nothing Is For Nothing
 Mayflower Books, 1968

Gibson, R. & Green, R.

Nothing Matters: A Book About Nothing
Iff Books, Arlsford,
Hants UK 2011

Gill, N. *Nothing Personal: Geographies of*
Governing & Activism in The British
Asylum System
RBS-IBG Series, Exeter UK 2015

Gilman, P. *Something From Nothing*
Scholastic Inc., New York 1993

Gizzi, P. *In Defense of Nothing:*
Selected Poems1987-2011
Wesleyan University Press, Middleton, 2015

Glass, H. *Nothing Personal*
Pedersen, Glasgow 1991

Goldschmidt, T. *The Puzzle of Existence: Why Is There*
Something Rather Than Nothing?
Routledge, London 2014

Good, P. *Language For Those Who Have Nothing:*
Mikhail Bakhtin & The Landscape of
Psychiatry
Kluwer Academic/ Plenum, London 2001

Govinnage, M. *Nothing Grows Under The Banyan Tree*
& Other Stories
Associated Newspapers of Ceylon
Columbo 2007

Graham, B. *Good For Nothing*
Skyscraper Pubns, Newbold on Stour
Warwickshire 2014

Grant, E. *Much Ado About Nothing: Theories of*
Space & Vacuum from The Middle Ages
To The Scientific Revolution
Cambridge University Press, UK 1981

Gray, J. *Worlds Out Of Nothing – A Course in The*
History of Geometry in The 19th Century
Springer, London 2010

Greaves, M.
Nothing Ever Happens On Sundays
BBC, London 1996

Green, H. *Nothing, Doting, Blindness*
Vintage Books, London 2008

Greenwald, A.
Nothing Feels Good:
Punk Rock, Teenagers and Emo
St Martin's Press, New York 2003

Groarke, L. *An Aristotelian Account Of Induction:*
Creating Something From Nothing
McGill-Queen's University Press
Montreal, 2009

Gussin, G. & Carpenter, E. (Eds)
Nothing
August & Northern Gallery For
Contemporary Art, London 2001

Guttridge, P.
Those Who Feel Nothing:
A BrightonMystery
Severn House Publishers, Sutton 2014

Hadfield, C.
The Nothing We Sink Or Swim In
Oversteps, Salcombe UK 2002

Hall, A. *Everything and Nothing*
Harper Collins, London 2011

Hall, K. *Running For Nothing – A Collection of*
Haiku and Tanka
Ram Publications, Isleworth, 2004

Handke, P. *Voyage To The Sonorous Land, or, The Art*
 Of Asking; and The Hour We Knew
 NothingOf Each Other
 Yale University Press, USA 1996

Hanspike, D. *Bobby Brown – The Truth, The Whole*
 Truth&Nothing But...
 Down South Books, USA 2015

Hardy, R. P. *The Life of St John of The Cross:*
 SearchFor Nothing
 Darton, Longman & Todd, London 1987

Harkess, K. *Wisp Unification Theory:*
 Particles of Nothingness
 Harkess Research, Basingstoke 2013

Harris, B. *The Nothing Book – Wanna Make*
 Something Of It?
 Harmony Books, New York 1979

Harris, J. *"Speak Useful Words or Say Nothing":*
 Old Norse Studies
 Cornell University, Ithaca New York 2008

Harris, M. *Why Nothing Works:*
 The Anthropology ofDaily Life
 Touchstone, Simon & Schuster
 London 1987

Harrison, S. *Doing Nothing – Coming To The End*
 Of The Spiritual Search
 Penguin, New York 2009

Harrop, I. *The Isobel Journal: Just A Northern Girl*
 From Where Nothing Really Happens
 Hot Key Books, UK 2013

Hart, M. *Nations Of Nothing But Poetry: Modernism,*
 Transnationalism and Synthetic Vernacular
 Writing
 Oxford University Press 2013

Hartmann, K.

Sartre's Ontology:
A Study of **Being & Nothingness**
In The Light of Hegel's, **Logic**
Northwestern UP, Evanston Illinois. 1966

Hass, A.W.

Auden's O:
The Loss of One's Sovereignty
In The Making of Nothing
State University of New York Press,
Albany, US 2013

Hassan, I. In Quest of Nothing:
Selected Essays 1998-2008
AMS, New York 2010

Heath, G. Believing in Nothing or Something: An
Approach to Humanist Beliefs and Values
Dowland, Chesterfield UK 2003

Heatley, M.

Dave Grohl: Nothing To Lose
Titan Books, London 2010

Heisig, J.W.

Nothingness and Desire: An East-West
Philosophical Antiphony
University of Hawaii, Honolulu 2013

Philosophers of Nothingness:
An Essay On The Kyoto School
University of Hawaii, Honolulu 2001

Helt, R.C. "... A Poet or Nothing At All"
The Tubingen & Basel Years
Of Hermann Hess
Berghahn Books, Oxford 1996

Hemmingway, E.

Winner Takes Nothing
Arrow Books, London 1994

Henderson, C.J. *Quantum Leap: Double or Nothing*
 Boxtree, London 1995

Henderson, D. *Introduction To Nothing*
 Bettiscombe Press, UK 1972

Hibbs, T.S. *Shows about Nothing:*
 Nihilism in Popular Culture
 Baylor UP, Waco Texas 2012

Highsmith, P. *Nothing That Meets The Eye:*
 The Uncollected Stories
 Bloomsbury, London 2005

Hightower, J. *There's Nothing In The Middle Of The*
 Road But Yellow Lines & Armadillos:
 A Work of Political Subversion
 Harper Collins, New York 1997

Hillary, E. *Nothing Venture, Nothing Win*
 Coronet, London 1977

Hintikka, J. *Defining Truth, The Whole Truth*
 & Nothing But The Truth
 Helsinki, 1991

Hird, T. *Nothing Like a Dame: My Autobiography*
 Zonderman, London 2001

Hobbiss, A. *Wanting For Nothing?*
 Nutrition & Budgeting Patterns
 Of Unemployed People
 Horton Publishing, Bradford 1991

Hobsbaum, P. *Some Lovely Glorious Nothing*
 Sceptre Press, Frensham UK 1969

Hobson, R.P. *Nothing Too Good For A Cowboy*
 McClelland & Stewart, Toronto 2005

Hoffman, L. *Nothing But A Drifter*
 Hale, London 1976

Hoffmann, P.
 Nothing So Absurd:
 An Invitation ToPhilosophy
 Broadview Press, Peterboro Canada 2003

Hogwood, B.W.
 If Consultation Is Everything, Then Maybe
 It's Nothing
 Dept of Politics, Strathclyde University 1986

Holder, R. *Nothing But Atoms and Molecules*
 The Faraday Institute,
 Cambridge UK 1993

Holland, H.S.
 Death Is Nothing at All
 Souvenir Press, London 1987

Holt, O. *If You're Second You Are Nothing:*
 Ferguson and Shankly
 Macmillan, London 2006

Hool, R. *No Nothing/Ric Hool*
 Collective Press, Bloomington 2009

Hope, J. *Nothing But The Truth:*
 Or A Tiny Book of Monsters
 Frederick Muller, London 1960

Horder, J. *Meher Baba & The Nothingness*
 Menard, London 1981

Horner, L. *The Pursuit of Zero & Nothingness*
 Janus, London 2001

House, I. *Nothing's Lost*
 Two Rivers Press, Reading 214

Hughes, G. & Blorn, P. (Eds.)
 Nothing But The Clouds Unchanged
 Getty Pubns, Los Angeles,
 US 2014

Hughes, R. *Nothing If Not Critical:*
 Selected EssaysOnArt and Artists!
 Penguin, London 1991

Hughes, S. *When Nothing You Ever Do Seems To Satisfy*
 Kingsway, Eastbourne UK 1994

Hughes, T. *Holding Nothing Back*
 Survivor, Eastbourne UK 2007

Hummel, L.M. *Clothed In Nothingness:*
 Consolation For Suffering
 Fortress Press, Minneapolis 2003

Hunt, R. *That's Nothing*
 Oxford University Press, 1996

Hunt, R. & Hunt, D.
 The Thief Who Stole Nothing
 Oxford University Press, 2014

Hunter, I. *Nothing To Repent:*
 The Life of HeskethPearson
 Hamilton, London 1987

Inkpen, M. *Nothing*
 Hodder, London 1995

Ishaya, P. *The Way of Nothing: Nothing In The Way*
 Barnes & Noble, New York, 2014

Jahanbegloo, R. *Time Will Say Nothing:*
 A Philosopher
 Survives An Iranian Prison
 University of Regina Press,
 Saskatchewan, 2014

James, D. *Money From Nothing*
 Stanford UP, Stanford USA 2014

Jamison, K.R. *Nothing Was The Same*
 Vintage Books, New York 2014

Janaway, C. (Ed.)
Willing & Nothingness:
Schopenhauer As Nietzsche's Educator
Clarendon Press, Oxford 1998

Jennings, J.
Nothing Like A Dream
PublishNation, London 2014

Jerome, J.K.
Three Men in a Boat:
To Say Nothing of the Dog
Penguin Classics, London 2014

Johnson, R.
Not Nothing:
Selected Writings 1954-1994
Siglio, New York 2014

Johnston, L.O.
Nothing To Fear But Ferrets
Chivers, Bath UK 2006

Jones, E.T.
All or Nothing:
The Cinema of Mike Leigh
Peter Lang, New York 2004

Jones, R. *A Propos of Nothing*
Copper Canyon Press,
WashingtonDC 2006

Joseph, J. *Nothing Like Love*
Enitharmon, London 2009

Kaplan, R. *The Nothing That Is:*
A Natural History ofZero
Oxford University Press, London 1999

Keating, K.
Nothing but the Truth: Essays in Apologetics
Catholic Answers, San Diego CA USA 2000

Keeler, C. *Nothing But... The Scandal That Helped*
 Bring Down A Tory Government
 New English Library, UK 1983

Kelley, P.B. *Stories For Nothing:*
 Samuel Beckett'sNarrative Poetics
 Peter Lang, Oxford 2002

Kelly, T. *Nothing Like The Wooden Horse*
 Red Squirrel Press, Morpeth UK 2009

Kelso, B.P. & Williamson, D.
 Shakespeare's, **Much Ado About Nothing**
 For Kids – 3 Short Melodramatic Plays for
 3 Group Sizes
 Playing With Publicity, US 2011

Kemp, C. *Negotiation Nothing:*
 Police Decision-Making in Disputes
 Avebury, Aldershot UK 1992

Kemp, G. *Nothing Scares Me*
 Faber & Faber, London 2006

Kennedy, D. (Ed)
 Nothing But Trouble?
 Religion & The Irish Problem
 The Irish Association, Dublin 2004

Kennedy, S. *Nothing But Horses*
 Melange Books, MN USA 2014

Kershaw, G. *Nothing But The Truth*
 Cambridge University Press, UK 1999

Khan, M.A. *We've Learned Nothing from History*
 Pakistan: Politics and Military Power
 Oxford University Press, UK 2005

Kharms, D. *Today I Wrote Nothing: The Selected*
 Writings of Daniil Khaarms
 Overlook, New York 2007

Kimberly, K.
 Ain't Nothing Like a Brooklyn Bitch
 White House Publishing, Kindle 2015

King, W. *Collections of Nothing*
 University of Chicago Press, US 2008

Kinsley, P.
 Three Cheers For Nothing
 Collins, London 1966

Kinslow, F.J.
 When Nothing Works Try Doing Nothing:
 How Learning to Let Go Will Get You
 Where You Want to Go
 Quantum Entrainment US 2010

Kirby, A. *Nothing To Fear: Risks and Hazards in*
 American Society
 University of Arizona Press, 1990

Kitaro, N. *Last Writings: Nothingness*
 & The Religious Worldview
 University of Hawaii Press, Honolulu 2013

Kit-Ching, C.L.
 From Nothing To Nothing: The Chinese
 Communist Movement and Hong Kong
 1921-36
 Hurst & Co, London 1999

Knight, I. *Nothing Remains But To Fight –*
 The Defence of Rorke's Drift, 1879
 Greenhill, London 1993

Kobialka, M.
 Further On, Nothing: Tadeusz Kantor'sTheatre
 University of Minnesota Press, US 2009

Kocbek, N.
 Nothing Is Lost: Selected Poems
 Princeton University Press, US 2004

Kochin, M.S. *Five Chapters on Character, Action,*
 Things, Nothing, and Art
 Pennsylvania State UP, USA 2009

Kogan, J. *Nothing But The Best: The Struggle For*
 Perfection at The Juilliard School
 Random House, New York 1989

Kolakowski, L. *God Owes Us Nothing: A Brief Remark On*
 Pascal's Religion & The Spirit ofJansenism
 University of Chicago Press, 1995

 Why Is There Something Rather Than
 Nothing? Questions from GreatPhilosophers
 Penguin, London 2008

Kolbowski, S. *Nothing and Everything*
 Gallerie Leonard and Bina Ellen Art
 Gallery, Montreal 2009

Koontz, D. *Fear Nothing*
 Bantam Books, New York 1998

Koontz, D.R. *The Paper Doorway:*
 Funny Verse&Nothing Worse
 Harper Collins New York 2001

Kraft, W.F. *A Psychology of Nothingness*
 Westminster Press, Philadelphia 1974

Kraus, C. *Video Green: Los Angeles Art*
 & The Triumph of Nothingness
 Semiotexte, New York 2004

Krauss, L.M. *A Universe from Nothing*
 Simon & Schuster, London 2012

Kray, R. *Nothing But Trouble*
 Sphere Books, London 2012

Kreider, T. *We Learn Nothing: Essays*
 Simon & Schuster, London 2013

Krishnamurti, J.
> *Letters To A Young Man: Happy Is*
> *The ManWho Is Nothing*
> Krishnamurti Fndn Trust, Hants 2004

Kroy, M. *Beyond Being & Nothingness*
> Navrang, New Delhi 1990

Kubanak, A-M.W.
> *Nothing Less Than An Adventure:*
> *Ellen Gleditsch – Her Life In Science*
> Crossfield, Calgary Canada 2010

Kuhlman, K.
> *Nothing Is Impossible With God*
> Bridge-Logos, New York 1996

Kuhn, H. *Encounters With Nothingness:*
> *An Essay On Existentialism, Etc*
> Methuen & Co, London 1951

Kundtz, D. *Nothing's Wrong: A Man's Guide To*
> *Managing His Feelings*
> Conari, Berkeley Calif. 2004

Lacy, C. *Being Not Nothingness*
> United Press, London 2011

Ladd, J. (Ed.)
> *Nothing Left Unsaid*
> Poetry Today, Llangollen Wales 1997

Lancaster, T.
> *I Regret Nothing*
> NAL/Penguin, New York 2015

Lange, R. *Sweet Nothing Stories*
> Mulholland Books, London 2015

Lawrence, D.
> *Nothing Like The Night*
> Thomas Dunne Books, London 2005

Laycock, S.W. *Nothingness & Emptiness:*
A Buddhist Engagement
With The Ontology Of Jean-Paul Sartre
State University of New York Press 2001

Leaper, E. *Barking At Nothing: A Fun Collection*
Of Verse of Children
Silverburn, Staffs UK 2010

Lechowski, A. *Definition of Time - Six Main Scientific*
Myths: Something on Nothing
Athena Press, London 2006

Leigh, M. *All or Nothing: Screenplay*
Faber & Faber, London 2003

Leigh, P. *I Never Done Nothing*
Hodder & Stoughton, London 1997

Lejeune, C. *Enjoy Making a Garden Out of Nothing*
Victor Gollancz, London 1964

Lerner, J. *You Got Nothing Coming*
Doubleday, London 2002

Lesynski, L. *Nothing Beats A Pizza*
Annick, Toronto Canada 2001

Levy, J. *Nothing Serious*
Melville House, Hoboken NJ US 2005

Lewis, F.C. *Nothing To Make A Shadow*
Iowa State University,
Ames US 1971

Lewis, J.D. *Nothing Less Than Victory:*
Decisive Wars
& The Lessons of History
Princeton University Press, 2010

Lewis, J.R *Nothing But Foxes/Roy Lewis*
Chivers, Bath UK 1984

Libby, A. *Mythologies of Nothing: Mystical Death*
In American Poetry 1940-1970
University of Illinois Press, Urbana1984

Lindemuth, C.
Nothing Save The Bones Inside Her
Hardgrave, Chesterfield,
Missouri, US 2013

Linder, M.
Nothing Less Than Literal:
ArchitectureAfter Minimalism
MIT, Cambridge Mass. US 2004

Lindgren, A. & Ross, T.
Nothing But Fun In A Noisy Village
Oxford University Press, UK 2015

Liu, J, & Berger, D.L. (Eds.)
Nothingness in American Philosophy
Routledge, New York 2014

Lively, P. *Nothing Missing But The Samovar*
& Other Stories
Heinemann, London 1978

Lo, K. *Cheap Chow:*
Chinese Cookery
On Next To Nothing
Pan Books, London 1977

Loren, R. *Nothing Between Us*
(A Loving On TheEdge Novel)
Penguin, New York 2015

Lubet, S. *Nothing But The Truth: Why Lawyers*
Don't, Can't, & Shouldn't Have To Tell
The Whole truth
New York University Press, 2001

Luke, D. *Nothing Remains Undone*
Hale, London 2014

Lyons, R.K. *Foreign Exchange Volume:*
 Sound & FurySignifying Nothing?
 NBER, Cambridge Mass. USA 1995

Mac Arthur, J. & MacArthur, J. Jnr.
 Anxious For Nothing:
 God's Cure For The Cares Of Your Soul
 D.C. Cook. Colorado Springs, US 2012

Macaulay, A. *My Uncle Had Nothing To Do With It*
 Oxford University Press, UK 1985

MacCaig, N. *Nothing Too Much & Other Poems*
 Stirling University, 1976

MacDonald, A. *Nothing But Trouble*
 A&C Black, London 2006

Maceoin, G. *Nothing Is Quite Enough*
 Hodder & Stoughton, London 1954

Macgann, B. *Hiatold: The Importance of Doing Nothing*
 Institute of Psychology, Dublin 1971

Madden, D. *Nothing Is Black*
 Faber & Faber, London 2013

Maksik, A. *You Deserve Nothing*
 John Murray, London 2011

Malcom, N. *Wittgenstein:*
 Nothing Is Hidden
 Oxford University Press, London 1988

Mares, F.H. *Much Ado About Nothing*
 The NewCambridge Shakespeare
 Cambridge University Press, UK 2003

Margulies, I. *Nothing Happens:*
 Chantal Ackerman's
 Hyperrealist Everyday Life
 Duke University Press, Durham NC1996

Mark, J. *Nothing To Be Afraid Of*
Puffin Books, London 1982

Marmysz, J.
Laughing At Nothing:
Humour As A Response To Nihilism
State University of N.Y. Press, 2003

Mars, M. *Double or Nothing for Alisha:*
InterracialLesbian Sex
BLVNP Inc, Walnut USA 2015

Marsden, S.
Nothing But The Boots
Xcite Books, London 2011

Marshall, S.
The Silver New Nothing:
EdwardianChildhood in the Fen
Penguin, London 1997

Marsland, B.
Lessons from Nothing:
Activities forLanguage Teaching
With Limited Time &Resources
Cambridge University Press, UK 1998

Mason, J. *Pranks For Nothing*
Egmont, London 2008

Matchett, E.
Journeys of Nothing in The Land of
Everything
Turnstone Books, London 1975

Mazierska, E.
Falco and Beyond:Neo Nothing Post Of All
Equinox, Sheffield UK 2013

McAlister, A.
Nothing To Do
Bodley Head, London 1989

McCaffrey, E. *Let Nothing Trouble You:*
 The Woman,
 The Guide
 & The Storyteller:
 St Teresa of Avila 1515-2015
 Teresian Press, Oxford 2015

McCarthy, J. & Williamson, B.
 Metallica:
 Nothing Else Matters
 Ominibus Press, London 2014

McClafferty, C.K.
 Something Out Of Nothing:
 Marie Curie& Radium
 Farrar, Strauss & Giroux, N.Y. 2006

McCourty, E. *Everything, Nothing*
 Knives, Forks & Spoons Press,
 Newton-le-Willows, UK 2010

McCrae, D. *Nothing Personal:*
 The Business of Sex
 Coronet, London 1993

McDonald, M. *Nothing Is Altogether Trivial:*
 AnAnthology
 Of Writing For Edinburgh Review
 Edinburgh University Press, 1995

McDonnell, P. *The Gift of Nothing*
 Little, Brown & Co, NY 2005

McEachem, C. ***Much Ado About Nothing***
 Arden Shakespeare, 2005

McFarland, I.A. *From Nothing:*
 A Theology of Creation
 WJK Press, Louisville Kentucky US 2014

McGowan, H. *Duchess of Nothing – A Novel*
 Faber, London 2006

McGuane, T.
>*Nothing But Blue Skies*
>Vintage, New York 1993

McLellan, A.
>*Nothing Sacred: The New Cricket Culture*
>Two Heads, London 1996

McMahon, G.
>*Beyond Here Lies Nothing*
>Solaris, Oxford UK 2012

McPherson, J. McPherson, G.
>*Ultimate Guide To Wilderness Living:*
>*Surviving With Nothing But Your Bare*
>*Hands And What You Find In The Woods*
>Ulysses Press, Berkeley California 2008

Mehtonen, P. (Ed)
>*Illuminating Darkness: Approaches to*
>*Obscurity & Nothingness in Literature*
>Finnish Academy of Science & Letters,
>Helsinki 2007

Melhuish, G.
>*Death & The Double Nature of Nothingness*
>Duckworth, London 1994

Memon, M.U. (Ed.)
>*The Colour of Nothingness:*
>*Modern Urdu Short Stories*
>OUP, Karachi/Oxford 1998

Mence, N.A.
>*Nothing Happens By Chance*
>Create Space 2014

Merton, T.
>*When The Trees Say Nothing:*
>*Writings on Nature*
>Sorin Books, Notre Dame 2015

Meyer, J. *Be Anxious For Nothing: The Art of*
 CastingYour Cares & Resting in God
 Warner, New York 2002

Miller, R. *Nothing Less Than Victory:*
 Oral History ofD-Day
 Random House, London 1993

Miller, V. *Nothing Is Impossible: A Glider Pilot's*
 Story of Sicily, Arnhem &
 The Rhine Crossing
 Barnes & Noble, UK 2015

Mills, L. *Nothing Simple*
 Penguin, London 2006

Milutis, J. *Ether:*
 The Nothing That Connects Everything
 University of Minnesota Press,
 Minneapolis, US 2006

Mitchell, S. *Innocence Proves Nothing – Death &*
 Intrigue in The Depths of Space
 Black Library, Nottingham 2009

Monagle, C. & Vardoulakis, D. (Eds.)
 The Politics of Nothing: On Sovereignty
 Routledge, London 2013

Monk, G. & Annwn, D.
 It Means Nothing To Me
 West House Books, Sheffield UK 2007

Morelock, N. *Nothing Other*
 Nothing Other Press, Somerset UK 2013

Morgan, E. *Nothing Not Giving Messages:*
 Reflectionson Work and Life
 Polygon, Edinburgh 1990

Morley, P. *Nothing*
 Faber &Faber, London 2000

Morris, M. *Nothing To Declare:*
Memoirs of A Woman Travelling Alone
Penguin Travel, London 1989

Morris, S. *Bar Nothing-Sarah Morris*
Jay Jopling/White Cube, London 2004

Morris, W.

The Well At The World's End – "Have
Nothing in Your House That You Do Not
Know To Be Useful Or Believe To Be
Beautiful"
Ballantine Books, New York 2015

Mosfeldt, M.

Bookkeeping Using Excel: How To
Perform Financial Bookkeeping &
Financial Reporting Using Excel, Only
Excel & Nothing But Excel
Create Space, Copenhagen 2012

Motiar, A.

The Reserve Bank: A License to Steal
Money From Citizens? How Money Is
Created From Nothing For Dummies
Strategic Books,
Houston US 2013

Motley, A.H.

Nothing Happens Until Somebody Sells
Something...
Alexander Hamilton Institute,
New York 1961

Mowbray, N.
Sweet Nothing
Orion Books, London 2014

Murningham, J.K.
Do Nothing! How To Stop Overmanaging
& Become A Great Leader
Portfolio/Penguin, London 2013

Murphy, A. *Nothing To Declare: The Drug Smuggler's*
Deadly Trade
O'Brien Press, Dublin 2008

Muto, K. *Christianity & The Notion of Nothingness*
Brill, London/Boston 2012

Myers, M. *It's Probably Nothing...* *
**or How I learned To Stop Worrying and*
Love My Implants- Surviving Cancer:
A Memoir in Poems
Simon & Schuster, New York 2013

Neary, J. *Something & Nothingness:*
The Fiction of John Updike & John Fowles
Southern Illinois UP,
Carbondale 1992

Neish, J. *Nothing In Return*
Outpost Publications, Walton on Thames
UK1976

Ness, P. *Topics About Which I Know Nothing*
Fourth Estate, London 2014

Newton, W. *Nothing Is For Free*
Hale, London 1980

Nicholson, H. *Nothing Left But Footprints*
Book Guild, Lewes UK 1996

Niemeyer, G. *Between Nothingness & Paradise*
Louisiana State UP, Baton Rouge 1971

Nishida, K. *Intelligibility & The Philosophy of*
Nothingness: Three Philosophical Essays
East-West Center Press,
Honolulu 1966

Nishitani, K. *Religion & Nothingness*
University of California Press
Berkeley/London 1988

Nobus, D. & Quinn, M.
> *Knowing Nothing, Staying Stupid:Elements*
> *For A PsychoanalyticEpistemology*
> Routledge UK 2005

Norman, K. & Robinson, J.R.
> *Say Nothing: The Art of Peter Kovalik*
> Mosaic, Oakville Ontario 1981

Novak, M.
> *The Experience of Nothingness*
> Harper, 1970

O'Hearn, D.
> *Nothing But An Unfinished Song:*
> *Bobby Sands, Hunger Striker Who Ignited*
> *A Generation*
> Nation Books, New York, 2006

Olazo, K. *The Truth About Managing Your Career...*
> *And Nothing But The Truth*
> Pearson/Prentice Hall,
> N Jersey 2006

Olson, C. *A Nation of Nothing but Poetry:*
> *Supplementary Poems*
> Black Sparrow Press,
> Santa Rosa California
> US 1989

O'Neal, D.
> *Meister Eckhart From Whom God Hid*
> *Nothing: Sermons, Writing & Sayings*
> New Seeds, London 2005

O'Neil, S. *Don't Mean Nothing:*
> *Short StoriesOf Vietnam*
> Black Swan, London 2002

Ormerod, R.
> *A Shot at Nothing*
> Constable, London 1993

Ortberg, J. *You Have A Soul: It Weighs Nothing*
But Means Everything
Zondervan, Grand Rapids Michigan 2014

Osgood, C. *Nothing Could Be Finer Than A Crisis*
That Is Minor In The Morning
Holt, Rinehart & Winston, New York 1979

O'Shea, D. *Take Nothing For The Journey:*
Meditation On Time & Place
Dominican Publications, Dublin 2013

Osho *Nothing To Lose But Your Head*
Rajineesh Foundation, London 1977

Osho & Osho *The Empty Boat:*
Encounters with Nothingness
Osho Classics, Switzerland 2011

The Path of Love: Understanding
That Nothing is Perfect in Life
Osho Classics, Switzerland 1977

Ovejero, J. *Nothing Ever Happens*
Hispabooks Publishing, Madrid Spain 2013

Oxford, A. *When I Have Nothing Left To Say*
Indigo Dreams, Stoney Stanton UK 2009

Parfitt, W. *The Something and Nothing of Death:*
A Book To Read Before You Die
PS Avalon, Glastonbury UK 2008

Park, B. & Garofoli, V.
Ma! There's Nothing To Do Here!
A Word From Your Baby-in-Waiting
Random House, London 2013

Park, L. *Entitled To Nothing: The Struggle for*
Immigrant HealthCare in The Age of
Welfare Reform
New York University Press, 2011

Parker, J. *Nothing For Nothing For Nobody:*
 A History of Hertfordshire Banks &Banking
 Hertfordshire Pbns, Stevenage UK 1986

Parrish, D. *Nothing I See Means Anything:*
 Quantum Questions, Quantum Answers
 Sentient Publications, Boulder US 2015

Parsons, T.
 Nothing Being Everything:
 Dialogues For Meetings In Europe
 Open Secret Publishing, London 2008

Partington, A.
 Much Ado About Nothing
 (Cambridge School Shakespeare)
 Cambridge University Press, UK 2014

Patel, R. *The Value of Nothing: How to Reshape*
 Modern Society and Redefine Democracy
 Picador, New York 2011

Pattison, V.
 Nothing But the Truth:My Story
 Sphere Books, London 2015

Pearlman, E.
 Nothing and Everything: The Influence of
 BuddhismOn The American Avant Garde
 1942-196
 Evolver Editions, Berkeley, US 2012

Percy, E. *What Clergy Do:*
 Especially When It Looks Like Nothing
 SPCK Books, London 2014

Perlin, R. *Intern Nation: How To Earn Nothing &*
 Learn Little in The Brave New Economy
 Verso, London 2012

Perrier, S. *Nothing Fatal*
 University of Akron, Ohio US 2010

Perry, H.J. *Nothing Too Personal:*
 Erotica Short Stories For Women
 HJP, London 2015

Peters-Smith, C. *Nothing To See And Nothing To Feel*
 Arthur House, Milton Keynes UK 2010

Pfister, S.F. *The Big Book About Nothing...*
 If Not Now... When?
 Wheatmark, Tucson US 2009

Philpott, J. *Anxiety: Nothing To Worry About – No*
 Jargon Comfortable Easy Read Book For
 Teenagers, Adults & Counsellors Dealing
 With Anxiety, Panic Attacks & Phobias
 Arthur House,
 Bloomington US 2014

Phinn, G. *And Nothing But The Truth:*
 Once Bitten Twice Shy
 Longman, Harlow UK 1987

Pipes, D. *Nothing Abides: Perspectives on*
 The Middle East and Islam
 Barnes & Noble,
 New York 2015

Plummer, R. *Nothing Need Be Ugly – The First 70 Years*
 Of The Design & Industrial Association
 D.I.A., London 1985

Politkovskaya, A.
 Nothing But The Truth: Selected Dispatches
 Harvill & Secker, London 2010

Pomerantsef, P. *Nothing is True and Everything is Possible:*
 The Surreal Heart of the New Russia
 Perseus Books, USA 2014

 Nothing is True and Everything is Possible:
 Adventures in Modern Russia
 Faber & Faber, London 2015

Poniatowski, E.
 Nothing, Nobody:
 The Voices of The MexicoCity Earthquake
 Temple University,
 Philadelphia US 1995

Popoola, T.
 Nothing Comes Close
 Accomplish Press, London 2012

Price, J.R. *Nothing Is Too Good To Be True*
 Hay House Inc, UK 2004

Prideaux, T.
 Love or Nothing:
 The Life & Times of Ellen Terry.
 Millington, London 1976

Priest,G. *One: Being An Investigation Into The Unity*
 Of Reality & Its Parts, Including The
 Singular Object Which Is Nothingness
 Oxford University Press, Oxford & NY 2014

Probert, I. *Johnny Nothing*
 Ian Probert, UK 2014

Pulinger, K.
 The Mistress of Nothing
 Serpent's Tail, London 2010

Quin-Harkin, J.
 Nothing In Common
 Bantam, 1988

Quintavalle, R.
 Make Nothing Happen
 Oystercatcher Press,
 Norfolk 2009

Quirk, T. *Nothing Abstract: Investigations In*
 The American Literary Imagination
 University of Missouri Press, US 2001

Rafelski, J. *The Structured Vacuum:*
 Thinking About Nothing
 Harri Deutsch, Thun Switzerland 1985

Rao, G.N. *Encounter With Nothing*
 Sri Venkateswara University,Tiraputi 1979

Rash, R. *Nothing Gold Can Stay*
 Canongate Books, Edinburgh 2013

Rasmussen, M.B. & Jacobsen, J. (Eds.)
 Expect Anything, Fear Nothing: The
 Situationist Movement in Scandinavia
 & Elsewhere
 Autonomedia, New York 2012

Read, P. *Returning To Nothing:*
 The Meaning ofLost Places
 Cambridge University Press, UK 1996

Reading, P. *Nothing For Anyone*
 Secker & Warburg, London 1977

Redfield, B.G. *Nothing Rhymes With Orange: Perfect*
 Words for Poets, Songwriters & Rhymers
 Penguin, London 2008

Reed, B. (Ed) *Nothing Sacred: Women Respond To*
 Religious Fundamentalism & Terror
 Thunder's Mouth Press/Nation Books
 New York 2002

Reed, J. *Nothing Whatever To Grumble At*
 Xlibris, London 2006

Reeve, C. & Parkin, K.
 Nothing Is Impossible:
 Reflections OnA New Life
 Random House, New York 2002

Rehn, J. *Nothing In Sight*
 University of Chicago Press, US 2005

Reinke, S. *Everybody Loves Nothing: Video 1996-2004*
Coach House Books, Toronto Canada 2004

Ritzer, G. *The Globalisation of Nothing 1*
Pine Forge Press/Sage London 2004

The Globalisation of Nothing 2
Pine Forge Press/Sage London 2007

Robbins, M.
Nothing Changes Until You Do:
A GuideTo Self-Compassion
& Getting Out Of Your Own Way
Hay House UK Ltd., 2014

Robbins, S.
Nothing Else Matters
Writers World, Enstone UK 1976

Roberts, D.D.
Nothing But History: Reconstruction
&Extremity after Metaphysics
University of California Press, Berkeley 1995

Roisman, H.M.
Nothing Is As It Seems: The Tragedy of
*The Implicit in Euripides' **Hippolytus***
Rowman & Littlefield, Oxford 1999

Rolfe, D. *Nothing Venture:*
The Story of The Houseof Citizenship
Hazell, Watson & Viney, Aylesbury 1961

Rollyson, C.E.
Nothing Ever Happens To The Brave:
TheStory of Martha Gellhorn
St Martin's Press, New York 1990

Rosen, S. *From Nothingness To Personhood:*
A Collection of Essays On Buddhism
From A Vaishnava Perspective
R. Lai & Sons, Vrindavan 2003

Ross, S. *Happy Yoga: 7 Reasons Why There's*
 Nothing To Worry About
 Regan Books, Los Angeles US 2003

Rotman, B. *Signifying Nothing:*
 The Semiotics of Zero
 Macmillan, Basingstoke UK 1987

Rowe, S.C. *Rediscovering The West:*
 An Inquiry Into Nothingness & Relatedness
 State University of New York Press 1994

Rumi, J.A. *Say Nothing – Poems of Jalal al-Din Rumi*
 In Persian and English
 Morning Light Press, Sandpoint ID 2008

Rundle, B. *Why Is There Something Rather Than*
 Nothing?
 Oxford University Press, UK 2004

Ruppert, J. *Nothing But The Truth: An Anthology of*
 Native American Literature
 Prentice-Hall, Upper Saddle River NJ 2000

Rushdie, S. *Is Nothing Sacred?*
 Granta, London 1990

Rushkoff, D. *Nothing Sacred:*
 The Truth About Judaism
 Crown Publishers, New York 2003

Russell, E.F. *Like Nothing On Earth*
 Methuen, London 1986

Russell, M. *Nothing Is Strange*
 Strange Books, London 2014

Rutherford, D. *Stop At Nothing*
 Macmillan, London 1983

Ryan, K. *All or Nothing*
 Atria, New York 2014

Rylands, G.
> *Quoth The Raven "Nevermore",*
> *Or, Much Ado About Nothing:*
> *An AnthologyOf Negation*
> Stourton, Hackney 1984

Sachs, A. *I Know Nothing: The Autobiography*
> The Robson Press, London 2014

Saer, J.J. *Nobody Nothing Never*
> Serpent's Tail, London 1993

Sartre, J-P.
> *Being and Nothingness:*
> *An Essay in Phenomenological Ontology*
> Routledge, London 2003

> *Mallarmé, Or The Poet of Nothingness*
> Penn State University Press 1988

Schertzer, M.
> *Cipher and Poverty:*
> *The Book of Nothing*
> Ekstasis Editions, Victoria, BC. 1998

Sears, D. O.
> *Tax Revolt:*
> *Something For Nothing in California*
> Harvard University Press,
> London 1982

Selwyn, F. *Nothing But Revenge:*
> *The Case of Bentley &Craig*
> Penguin, London 1991

Sempé, J.J.
> *Nothing Is Simple*
> Macdonald, London 1964

Sewell, B. *Nothing Wasted:*
> *The Paintings of Richard Harrison*
> Tauris, London 2010

Seyfarth, L. *Nadia Lichtig. Pictures of Nothing*
Kerber Christof Verlag, Bielefeld, 2015

Shakespeare, W. *Much Ado About Nothing*
Wordsworth Classics, London 1995

Shakespeare, W. & Book Caps
*Much Ado About Nothing in Plain &
Simple English: A Modern Translation
& The Original Version*
Book Caps, London 2012

Shapiro, E. *Nothing like a Dame: Conversations with
The Great Women of The Musical Theatre*
Oxford University Press, London 2014

Shaw, R. *Nothing To Hide: Secrecy, Communication
And Communion In The Catholic Church*
Ignatius Press, San Francisco US 2008

Sheldon, S. *Nothing Lasts Forever*
William Morrow, New York 1994

Shen, P. *Nothing Can Possibly Go Wrong*
First Second, London 2013

Shengold, L. *The Boy Will Come To Nothing:
Freud's Ego Ideal and Freud as Ego Ideal*
Yale University Press, US 1993

Sheppard, B. *Just About Nothing – The Hardest Part of
Doing Nothing Is Knowing When To Quit*
McAra Printing, Calgary Canada 1977

Shinagawa, M. (Ed.)
Talk To A Stone: Nothingness
Tabori & Chang, New York 1998

Shoham, S. *The Bridge To Nothingness:
Gnosis, Kabbala, Existentialism &
The Transcendental Predicament of Man*
Associated University Presses, London 1994

Shulman, T.D.
 Something for Nothing:
 Shoplifting, Addiction and Recovery
 Infinity Publications,
 Philadelphia US 2004

Silberts, B.
 Nothing But Prairie & Sky: Life on The
 Dakota Range in The Early Days
 University of Oklahoma Press, US 1988

Silman, J. *Signifying Nothing*
 Minerva Press, London 1997

Silver, H. *Nothing But The Present,*
 Or Nothing ButThe Past
 Chelsea College, London University 1977

Simpson, M.
 The Windy Side of Care:
 A Reading of Shakespeare's,
 Much Ado About Nothing
 Greenwich Exchange, 2007

Singh, T. *"Nothing Real Can Be Threatened" –*
 Exploring A Course in Miracles
 Life Action Press, Los Angeles 1989

Sklenar, R.
 The Taste For Nothingness:
 A Study of Virtus & Related Themes
 In Lucan's, ***Bellum Civile***
 Ann Arbor, Belford 2003

Smith, R.P.S. & Smith, E.G.
 How To Do Nothing With Nobody
 All AloneBy Yourself
 Tin House Books, New York 2010

Solly, R. *Nothing Over The Side: Examining Safe*
 Crude Oil Tankers
 Whittles, Caithness Scotland 2010

Solove, D.J. *Nothing To Hide: The False Tradeoff*
 Between Privacy And Security
 Yale University Press, 2011

Soltis, S. *Nothing Life a Puffin*
 Walker, London 2012

Sommer, L. *The Hidden Camino – A Spiritual Journey*
 Into The Heart Of The Pilgrimage,
 Where Nothing Is At It First Seems
 The Sommer Institute, Byron Bay,
 Australia 2014

Sondermann, R. *Nothing But Art:*
 Elfriede Lohse-Wachtler 1899-1940
 Tower Books, London 2013

South, J.B. & Carveth, R.
 Mad Men and Philosophy:
 Nothing Is As it Seems
 John Wiley & Sons, New Jersey 2010

Southby-Tailyour, E.
 Nothing Impossible:
 A Portrait ofThe Royal Marines
 Third Millenium Publishing, London 2010

Soyinka, W. *The Credo of Being & Nothingness*
 Spectrum Books, Ibadan 1991

Spada, V. *I am Nothing*
 Cross Editions, New York 2014

Spence, E. *The Nothing-Place*
 Oxford University Press, UK 1972

Spier, P. *Nothing Like A Fresh Coat Of Paint*
 World's Work, Tadworth UK 1980

Stadlen, N. *What Mothers Do:*
 Especially When It Looks Like Nothing
 Piatkus Books, London 2005

Standish, R.
 Theory of Nothing
 Booksurge, Australia 2006

Stansall, D. & Tyler, D.
 A Hiding To Nothing:
 The Use of The Whip
 In British Horse Racing
 Animal Aid, Tonbridge UK 2004

Starr, J. *Nothing Personal*
 No Exit Press, Harpenden 2014

Stein, H. *Longing For Nothingness:*
 Resistance, Denial & The Place of Death
 In The Nursing Home
 Jason Aronson, Lanham Md 2010

Steinberg, J.
 All or Nothing:
 The Axis &The Holocaust1941-1943
 Routledge, London 1990

Steiner, R. *Nothing Lasts Forever:*
 3 Novellas
 Counterpoint Press,
 Berkeley CA 2015

St John, P. *Nothing Else Matters*
 Kingsley Press, Powys UK 2007

Strean, H.S.
 When Nothing Else Works – Innovative
 Interventions with Intractable Individuals
 Jason Aronson, London 1998

Sulkin, A., Johann, A. & Desilets, M.
 Robots Feel Nothing When They Hold Hands
 Chronicle Books, San Francisco US 2012

Swan, R. *Assuming Nothing*
 Soft Skull Press, Berkeley CA US 2010

Szymborska, W. *Nothing Twice: Selected Poems*
Barnes & Noble, New York 1997

Takamutsu, S. *Architecture & Nothingness*
L'Arca Edizioni, Milan 1996

Tate, J. *Nothing Is Forever*
Headline, London 2012

Tavakoli, R. *Nothing & The Other:*
Jacques Derrida Applied
Author House, Milton Keynes UK 2007

Tellegen, T. *About Love & Nothing Else*
Shoestring Press, Beeston 2008

Teller, J. *Nothing*
Atheneum Books NY 2010

Teresa of Avilon

Let Nothing Disturb You:
30 Days With A Great Spiritual Teacher
Ave Maria Press, Notre Dame, Indiana 2008

Terrell, C. *Fit For Nothing*
Axis Ed, Shrewsbury UK 2011

Thayne, R. *Nothing To Lose*
Mills & Boon, London 2014

Thich Nhat Hanh

Is Nothing Something?
Kids' Questions & Zen Answers
About Life, Death, Family,
Friendship, & Everything In-Between
Plum Blossom Books, London 2014

Thompson, J. *Nothing More Than Murder*
Orion Books, London 2004

The Nothing Man
Mulholland Books, London 2014

Thorp, R. *Nothing Lasts Forever*
Graymalkin Media, New York 2012

Toczek, N.
Complete Strangers Tell You Nothing
Xenia Press, Bristol UK 1979

Tole, R. *Nothing Spiritual About Chaos:*
A PracticalGuide For Baptist Church
Secretaries & Administrators
Baptist Union of GB, 2006

Tollifson, J.
Nothing To Grasp
Non-Duality Press, Salisbury UK 2012

Tomlin, L.
Point Blank; Nothing To Declare;
Operation Wonderland/Morphine & Roses
Performance Text & Critical Essays
Intellect Books, Bristol UK 2007

Tracey, C.G.
All For Nothing?
My Life Remembered
Weaver Press, Harare, 2009

Tracy, H.L.W.
Mind You, I've Said Nothing:
Forays In The Irish Republic
White Lion Publishers, London 1973

Trigg, D. *The Aesthetics of Decay: Nothingness,*
Nostalgia, & The Absence of Reason
Peter Lang, New York 2006

Tsur, R. *On The Shore of Nothingness:*
Space, Rhythm & Semantic Structure In
Religious Poetry & Its Mystic-Secular
Counterpart - A Study in Cognitive Poetics
Imprint Academic Ltd, Thorverton 2003

Tullian, T. *Jesus + Nothing = Everything*
Crossway, Wheaton, Illinois US 2011

Turok, B. *Nothing But The Truth:*
Behind The ANC'sStruggle Politics
Jonathan Ball,
Johannesburg SA 2003

Twain, M. *Mark Twain – **A Tramp Abroad**:*
"Don't Go Around Saying The World
Owes You A Living. The World Owes
You Nothing. It Was Here First".
Echo Library,
Teddington UK 2006

Twelker, U. *Georgie Fame:*
There's Nothing Else ToDo.
Life and Music
Hudson Music 2014

Tymieniecka, A.T.
Why Is There Something Rather Than
Nothing? Prolegomena To The
PhenomenologyOf Cosmic Creation
Van Gorcum & Co, Assen 1966

Unwin, R. *Nothing Gained by Overcrowding*
Routledge, London 2014

Van De Watering, J.
A Glimpse of Nothingness:
ExperiencesIn An American Zen Community
Houghton Mifflin, Boston 1975

Varnedoe, K. *Pictures of Nothing:*
Abstract Art Since Pollock
National Gallery of Art, New York 2006

Vieceli, E. & Appignanesi, R.
Manga Shakespeare:
Much Ado AboutNothing
SelfMadeHero, London 2009

Vienne, V.

 The Art of Doing Nothing
 Random House,
 New York 1998

Vio, E. *Airy Nothing*
 Downlander,
 Eastbourne UK 1982

Vogt, C. *Photographic Notes:*
 Everything is Important,
 Nothing is Important
 Edition Stemmie,
 Zurich 1998

Von Elchendorff, A.

 From the Life of a Good-for-nothing
 Create Space Independent Publishing
 Bilingual Edn German/English 2015

Vonnegut, K.

 Nothing Is Lost Save Honour:Two Essays
 Nouveau Press, Jackson Miss. 1984

Von Ziegesar, G.

 Nothing Can Keep Us Together
 Bloomsbury, London 2005

Vorpsi, O.

 Nothing Obvious
 Scalo, Zurich 2001

Waghorn, N.

 Nothingness & The Meaning of Life:
 Philosophical Approaches to Ultimate
 Meaning Through Nothing & Reflexivity
 Bloomsbury, London 2014

 "Signifying Nothing":
 Nothingness and
 It's Relationship to the Meaning of Life
 University of Reading, UK 2008

Wake, B. *Doing Nothing*
 Windows, Liverpool 1982

Walker, A. *The Cost of Doing Nothing:*
 The EconomicsOf Obesity in Scotland
 National Obesity Forum,
 Nottingham 2003

Walker, G.F. *Nothing Sacred:*
 Based on **Fathers & Sons,**
 By Ivan Turgenev
 Coach House Press,
 Toronto 1988

Walker, K. *Nothing Easy*
 KW Publications, Bilton 2012

Wallace, I. *Nothing Quite Like It*
 Elm Tree, London 1982

Walsh, A. *Nothing Ventured:*
 Disabled People TravelThe World
 Harrap Columbus,
 London 1991

Ward, A. *Nothing to See Here: A Guide*
 To The HiddenJoys of Scotland
 Pocket Mountains, 2011

Wargo, R. *The Logic of Nothingness:*
 A Study of Nishida Kitaro
 University of Hawaii Press,
 Honolulu, 2005

Waring, M. & Steinem, G.
 Counting For Nothing: What Men Value
 & What Women Are Worth
 University of Toronto Press, Canada 1999

Warren, T. *Nothing Lasts Forever*
 Cirencester, Gloucestershire
 Memoirs Dec 2012

Washington, D. & Burdett, L.
"Much Ado About Nothing" :
ShakespeareCan Be Fun
Firefly Books, Ontario,
Canada 2002

Waters, C. *Bob Dylan – Nothing But Mystery*
Argyll Publishing, Glendaruel 2010

Watkins, D.
'Fear Nothing':
The History of 501
(County Of Gloucester) Squadron,
Royal AuxiliaryAir Force 1929-57
Cowden, Newton 1990

Watson, P.
The Age of Nothing:
How We Have Sought To Live
Since The Death of God
Weidenfeld & Nicholson,
London 2014

Watts, A. *The Essence of Alan Watts:*
v3 = Nothingness
Celestial Arts, Millbrae 1974

Wayne, P. (Ed.)
Much Ado About Nothing
The New Clarendon Shakespeare
Oxford 1938

Wayner, P.
Disappearing Cryptography:
Being & Nothingness On The Net
AP Professional,
Boston 1996

Webb, J. *Nothing:*
From Absolute Zero to Cosmic Oblivion:
Amazing Insights into Nothingness
Profile Books, London 2013

157

Miscellaneous

Anon *Nothing Is More Important:*
A Nuclear Catastrophe
Can & Must Be Prevented
Peace & Socialism, Prague 1984

Archdeacon, R.E.
'Things Which Are Not':
Ideas of "Nothing" In Renaissance Literary
& Philosophical Discourse
Thesis, University of Southampton 1997

Bani, N. *The Eclipse of Being: Heidegger*
On The Question of Being & Nothing
& The Ground of Nihilism
Thesis/University of Warwick 2002

Barrett, L.L. *"Foundress of Nothing":*
Vocational & Sexual Need
In George Eliot's Heroines
Thesis, University of Cambridge 1987

Cage, J. *'Lectures on Nothing'*, in **Silence**,
Wesleyan UP, 1961

Case, A. *'You are your life, & nothing else'*,
New Philosopher, 6th January 2014

Cavendish-Jones, C.
Pavillioned on Nothing:
Nihilism & Its Counterforces
In The WorksOf Oscar Wilde
Thesis, University of St Andrew's 2013

Clare, N.J. *On Nothing: A Kristevan Reading of*
Trauma,Abjection & Representation
Thesis, University of Leeds 2004

Feydeau, G.
 'Don't Walk About With Nothing On',
 In *From Marriage to Divorce*
 Oberon, London 1998

Fielding, H. & Murphy, A.
 'Essay on Nothing' (1743), in *The Works*
 Of Henry Fielding, Esq.: Miscellaneous
 Wesleyan Edition 2001

Hollier, J. *Circles Nothing But Circles: Map & Guide*
 To The Stone Circles of England, Scotland
 & Wales
 UK 1989

H.R.W. *Nothing Unusual:*
 The Torture of Childrenin Turkey
 Human Rights Watch, New York 1991

Knox, K. *Disputes About Nothing: Natural*
 Philosophy in Late Georgian Cambridge
 Thesis, University of Cambridge 1995

Newberry, L.R.
 "Hunger Is Nothing":
 Mid-19th Century Fictional Narratives
 Of Consumption, Abegnation & Desire
 Thesis, University of London 2006

New Scientist.
 Nothing: From Absolute Zero to Cosmic
 Oblivion: Amazing Insights into Nothingness
 Profile Books Ltd, London 2013

N.S.F. *Home Sweet Nothing: The Plight of*
 Sufferers from Chronic Schizophrenia
 National Schizophrenia Fellowship 1979

Reardon, J. *The Uncontrollable Discourse or Why*
 Contemporary Art Has Nothing In
 Particular To Do With Democracy
 Thesis, University of London 2005

Shaw, B. *The Dying Tongue of Great Elizabeth...*
 (A Review of Sir H. Tree's,
 "Much Ado About Nothing", *1905,*
 *Reprinted from **The Saturday Review**)*
 To Which Is Added A Foornote by W.Poel
 Shakespeare League, London 1920

Sheehan, P.G. *Nothing Human: Narrative & Human*
 Orientation in Literary Modernism
 Thesis, University of London 1999

Smith, B.C. *Samuel Beckett's **'Texts For Nothing'***
 Thesis, University of East Anglia 1978

The Party History Institute of The CC
Of The Worker's Party of Korea
 Envying No-One and Nothing in the World
 Foreign Languages Publishing House
 Pyongyang, Korea 1977

Trifler, T. *The Elegy of Nothing,Dedicated To Nobody*
 With a Postface by T. Trifler, Esq.
 Of The Middle Temple
 T.Cooper, London 1742

Tuer, A.T. *The Book of Delightful & Strange Designs*
 /Being 100 Facsimile Illustrations of The
 Art of The Japanese Stencil Cutter To
 Which The Gentle Reader is Introduced by
 One Andrew T. Tuer , F.S.A. Who Knows
 Nothing At All About It
 The Leadenhall Press, London 1893

Wilmot, J. (Earl of Rochester)
 'Upon Nothing' (1680) in **The Book of**
 Restoration Verse, Ed. Braithewaite, M.S.
 Brentano, NY 1910 / Bartleby.com 2013

Wright, J. *'Nothing Else But Slaves': Britain & The*
 Central Saharan Slave Trade In The 19th Century
 Thesis, University of London 1998

(B) MU(SIC) SCORES & SONGS

Hall, E.V. *Is It Nothing To You?*
 Novello & Co Ltd,
 London 1894

Hamlisch, M. *Nothing*
 From *A Chorus Line* 1975

Hammond, F. Nothing But The Hits
 CD/MP3 2003

Harper, F. *A Faded Red Rose, Nothing More*
 London 1881

Harrison, P. *Idle Dan or Nothing To Do*
 Joseph Williams, London 1959

Hartley, F. *Life Is Nothing Without Music*
 Peter Maurice Music & Co,
 London 1946

Hershey, U. H. *Nothing To You?*
 Morgan & Scott, London 1906

Hiller, H.C. *Nothing But A Dream*
 D. Davison & Co, London 1882

Himmel, F.H. *Ah! Nothing Can Ever Be Lasting*
 Metzler & Co, London 1860

Hirsch, L.A. *Nothing Ever Worries Me*
 Heif & Hager Co, New York 1907

Hodgson, C. *The Young Lady With Nothing To Wear*
 London 1858

Hudson, Mr. *I Never Says No To Nobody*
 London 1868

Iceage *You're Nothing*
 Matador Records 2013

Ice-T *Something for Nothing- Art of Rap*
 Prime Instant Video 2012

Johns, C.E. *Nothing On Earth Continues In One Stay*
 R. Cocks & Co, London 1884

Johnson, R. & The Irregulars
 Here Goes Nothing
 CD/MP3D 2015

Johnston, B. *Ponder Nothing*
 CD/MP3D 2007

Jones, A. *There's Nothing Of That About Me*
 Leeds 1877

Jones, I. *Home And Nothing Like This*
 Leo Feist, New York 1902

Jones, S. *Nothing At All, At All*
 Chappell & Co, London 1913

 Nothing But Nerves
 Hopgood & Crew, London 1898

Kerker, G.A. *Girls Are Nothing But Roses*
 T.B. Harms & Co, New York 1897

King, B.E. *I (Who Have Nothing)*
 Alco Records US 1963

Klein, A. *It's Nothing To Do With You*
 Reynolds & Co, London 1930

Knopfler, M. *Money For Nothing*
 Wise Publications, London 1988

Knox, P.J.	*'Nothing From Nothing Leaves Me'* Francis, Day & Hunter, London 1908
Korngold, E.W.	
	Much Ado About Nothing: *Opus 11* Schott & Co, London 1926/CD 2010
Lancen, S.	*Less Than Nothing* Peters Edition & Hinrichsen Edition, New York. Printed London 1956
Lane, S.	*Nothing Like It* Francis, Day & Hunter, London 1891
Lawrence, E.	*You've Got Nothing To Worry About* Francis, Day & Hunter, London 1901
Lawrence, J.	*All Or Nothing At All* Leeds Music Corp, New York 1960
Le Brunn, G.	*Good-For-Nothing Nan* Francis, Day & Hunter, London 1893
Leigh, F.W.	*Good – For Nothing* Francis, Day & Hunter, London 1907
Leo, F.	*"Nothing Shall Part Us Now"* Francis, Day & Hunter, London 1899
Lester, G.	*It May Look Nothing To You* E.R. Smith & Co, London 1890
Lissie	*Nothing Else Matters* (From the Album, ***Covered Up With*** ***Flowers***) MP3D 2012
Loehr, F. N.	*Nothing Else* Enoch & Sons, London 1883
Lord, D.	*Nonsongs:* *Six Songs About Nothing In Particular* Universal Edition, London 1974

Lucier, A.	*Nothing Is Real* CD 2003
Lutz, M.	*It's Nothing To Do With Me* London 1880
Macglennon, F.	*Say Nothing* Francis, Day & Hunter, London 1899
Maconchy, E.	*Our Life Is Nothing But A Winter's Day* Chester Music, London 1976
Madonna	*Nothing Fails* (From the Album, ***American Life***) Maverick – Warner Bros UK 2003
	Nothing Really Matters (From the Album, ***Ray of Light*** 1998) Maverick –Warner Bros 1999
Mahoney, J.F.	*Good-For-Nothing Jim* Jos. W. Stern & Co, New York 1917
Marriott, S. & Lane, R. (Small Faces) 	*All or Nothing* Decca London1966/DVD 2012
Marzials, T.	*Ask Nothing More* Boosey & Co, London 1883
Masser, R.	*Nothing's Gonna Change My Love For You* Rondor Music, London 1985
Mellin, E.F.	*Let Nothing Disturb Thee* Weekes & Co, London 1887
Mellor, T.	*Home Sweet Home Ain't Nothing Like This* Reeder & Walsh, London 1906
Merrion, R.	*Nothing To Say* A. Hays, London 1884

Meshuggah *Nothing*
 Avalon, CD/MP3D 2002

Metallica *Nothine Else Matters*
 Elektra 1992 /MP3D 2014

Meyer, F. *Nothing Venture, Nothing Gained*
 A.P. Schmidt, Boston 1912

Meyer, G. *Nothing To Do Until Tomorrow*
 F.B. Haviland Publishing Corporation,
 New York 1911

Mihaud, D. *Le Boeuf Sur Le Toit, ou, The Nothing
 Doing Bar*
 La Siréne Musicale, Paris 1920

Modest Mouse
 Building Nothing Out of Something
 Up Label, 1999/Vinyl/MP3D 2015

Monaco, V. *There's Nothing Sweeter Than A Girl
 From Dixieland*
 Les. Feist, New York 1917

Monckton, L. *I Know Nothing Of Life*
 Chappell & Co, London 1918

 There's Nothing Much More To Say
 Chappell & Co,
 London & Melbourne 1904

Moore, T. *Oh! Nothing In Life Can Sadden Us*
 Hime, Dublin (1800?)

Mott, R. *Love, If For Nothing Else*
 Weekes & Co, London 1913

Murphy, C. W.
 *There's Nothing So Bad But It Might
 Have Been Worse*
 Francis, Day & Hunter, London 1910

Murray, F.	*About The Matter I Ain't Got Nothing To Say* Francis, Day & Hunter, London 1910
Nelson, J.	*Nothing Without You* (From the Album **Shifting The Atmosphere**) ITunes 2011
N.E.R.D.	*Nothing* Polydor Records CD/MP3D 2010
Nivea	*Tell Me She's Nothin'* (From the Album, *Animalistic*) U-Tube 2006
Nothing	*Guilty of Everything* Relapse Label. CD/MP3D 2014
Nothing More	*Nothing More* Eleven Seven Music CD/MP3D 2014
O'Donnell, C.	*Nothing To Do Till Tomorrow* J. Morris Music Co, New York 1911
Ouseley, F.A.G. (Sir)	*Is It Nothing To You?* Novello & Co, London 1909
Overstreet, P. & Schilitz, D.	*When You Say Nothing At All* BMG Music Publishing, London 1999
Paans, W.J.	*Oh, That's Nothing – Ca S'ra Rien* E. Ascherberg & Co, London 1905
Palestrina, G.P.	*Is It Nothing To You?* J.A. Sharp, London 1931
Paley, H.	*There's Nothing Left To Say Except Goodbye* Jerome H. Remick, Detroit & N. York 1917
Palmer, J.M.	*Nothing Venture, Nothing Have* Welkes & Co, London 1891

Pearson, W.D. *Nothing Is Here For Tears*
Hinrichsen Edition, London 1853

Pedrette, E.A. *Is It Nothing To You?*
G. Schirmer, New York 1972

Perpignan, F. *Nothing But Love*
E. Aschterberg & Co, London 1904

Philips, M.F. *Nothing Venture*
Chappell & Co, London 1918

Placebo *Without You I'm Nothing*
Hut & Virgin Records 1998

Plumstead, M. *Nothing Like Grog*
Elkin & Co, London 1949

Pochon, A. *Nothing Real*
A. Fischer, New York 1922

Pop Beatz *Nothing Really Matter -Tribute to Mr Probz*
MP3D 2015

Powell, R. J. *Is It Nothing To You?*
H.W. Gray Co,
New York 1963

Prince *Nothing Compares 2 U*
IMP, London 1986

Radford, J. *Nothing But The Rolling Stones :*
50^{th} Anniversary Tribute
U-Tube/MP3 2012

Rascal Flatts *Nothing Like This*
Big Machine 2010. CD/MP3D 2014

Reagan, W. & United Pursuit
Nothing I Hold On To
(From the Album, ***Live At The Banks House***
2011) MP3D

Reeve, W. *Nothing But A Place*
 Preston & Son, London 1795

Rehman, C. *Do Nothing Till You Hear From Me*
 Trebush Publishing Co,
 New York 1908

Richardson, A. *Is It Nothing To You?*
 H.W. Gray & Co, New York 1914

Robyn, A.G. *There's Nothing New To Say*
 Jos. W. Stern & Co, New York 1897

Rock Doctors *Nothing But The Rolling Stones*
 MP3 2014

Rogers, C. & Hammerstein, O.
 There Is Nothing Like A Dame
 Williamson Music, Hal Leonard Corp.

Rouse, J. *Nothing Gives Me Pleasure*
 Slow River Records. Pubco 2002

Rover, H. *Nothing Is Coming In*
 Hopgood & Crew, London 1897

Ryan, D. *Nothing Hurts Like A Heartache*
 Sharpe Music, Dublin 2011

Samuels, W.G. *There's Nothing The Matter With Me*
 That A Kiss Can't Cure
 London 1946

Sandals *Nothing*
 Open Toe Records 1992

Schubert, H.W. *I Was Born With Nothing*
 Delmar Music Co, Montreal 1909

Sheehan, T. *Nothing But A Child*
 (From the Album, ***Where You Are*** 1998)
 MP3D

Silent Line *Layers of Nothing*
 CD/MP3D 2015

Sinatra, F. *All or Nothing At All*
 Columbia 1943

 Nothing But The Best
 MP3D 2014

Slim, L. *Nothing But The Devil*
 (From the Album, ***I'm A Rolling Stone***)
 Swamp Blues 2015

Smith, E. *"There's Nothing Like Having A Home Of
 Your Own"*
 Harry Von Tizer Publishing Co,
 New York 1904

Somervell, A. *Is It Nothing To You?*
 Boosey & Co, London 1936

Southam, T. *Nothing Is Lost, Sweet Self*
 Turret Books, London 1967

Spock's Beard *The Great Nothing*
 (From the Album, *V*
 InsideOut Music US 2000

Stamper, D. *There's Nothing Dear,
 I Wouldn't Do For You*
 Penn Music Co, New York 1913

Stanford, C.V.
 Much Ado About Nothing
 Bosey, S.I. 1901

Starship *Nothing's Gonna Stop Us Now*
 (From the Album, ***The 80's***)
 Grunt Records 1987 /MP3D 2013

Staunton, H. *I Want Nothing To Do With You*
 Reeder & Walsh, London 1906

Sting	*Nothing Like The Sun* Hal Leonard Publishing Corporation Winona, MN 1998
Stock, M.	*Nothing's Gonna Stop Me Now* Warner Bros Music, IMP, London 1987
Striking Matches	*Nothing But The Silence* Caroline International. CD/MP3D 2015
Stromberg, J.A.	*Nothing Doing* M. Wilmark & Sons, New York 1900
Swain, C.	*There's Nothing Like One's Own Home* Fanny H. Henslowe, London (1840?)
Tabrar, J.	*There Is Nothing So Lovely As Woman* Francis, Day & Hunter, London 1893
	There's Nothing In It Hopgood & Crew, London 1888
Tagore, R.	*Yes, I Know, This Is Nothing But Thy Love* Enoch & Sons, London 1920
Tann, H.	*Nothing Forgotten* Oxford University Press, New York 1999
Taylor, C.J.	*It's Nothing To What He's Going To Have* Francis, Day & Hunter, London 1907
Tennant, N. & Lowe, C. (Pet Shop Boys)	*Nothing Has Been Proved* Cage Music/IMP, London 1989
Tennent, H.M.	*If You've Got Nothing Else Better To Do* Chappell & Co, London 1913
	There's Nothing Like London Town J.B. Cramer & Co, London 1915

The Canton Spirituals Album
> *Nothing But The Hits*
> CD/MP3 2004

The Flirtations
> *Nothing But A Heartache*
> Deram Records 1968

The Heavy Metal Kids
> *Ain't Nothing But A House Party*
> (From the Album, ***Live at The Trent Poly***
> *1975)*. MP3 2012

The Hollies *Nothing Else But Love*
> (From the Album, ***30th Anniversary***
> ***Collection1963-1993***, 1993)

The Joneses *Baby (There is Nothing You Can Do*
> Dorsey 1979

The Psychedelic Furs
> *All Of This And Nothing*
> Coumbia Records 1988
> CD/PM3D 2000

The Script *Nothing*
> (From the Album, ***Science & Faith***)
> Epic/Phogenic 2010

The Searchers *Sweet Nothings*
> (From the Album, ***The Searchers At The***
> ***Star-Club***)
> Bear Family Records, LP CD 1963

The Stingrays *These Cats Ain't Nothing But Trash!!!*
> Big Beat Records 1983/VHS Tape 1984

The Supremes *Nothing But Heartaches*
> Motown Records 1965

Thompson, L. *I Have Nothing*
> IMP, London 1993

Ting Tings	*We Started Nothing* Columbia Records 2008
Tosh, P. & Guthrie, G.	
	Nothing But Love Rolling Stones Records 1981
Trevor, C.	*If You Have Nothing More To Tell* Novello & Co, London 1908
Tull, J.	*Nothing Is Easy:* *Live at The Isle of WightFestival 1970* Eagle, 2004
Van Dyk, P	*Nothing But You* Vandit, Positiva, CD 2003
Von Tizer, H.	*Nothing Ever, Ever, Ever, Hardly Ever* *Troubles Me* York Music Co, New York 1908
	The Little Good-For-Nothing's Good For *Something After All* Harry Von Tizer Music Publishing Co, New York 1918
Vousden, E.	*Just Because He's Nothing Else To Do* Francis, Day & Hunter, London 1896
Wale	*Album About Nothing* Atlantic Records 2015
Walker, W.R.	*You Didn't Have Nothing When You* *Knocked At The Door* Ted Snyder Co, New York 1911
Wallis, W.H.	*Nothing At All - What Have We Got To* *Worry About?* Lawrence Wright Music Co, London 1914
	We All Came Into The World With Nothing Star Music Publishing Co, London 1907

Watson, R.　　　*Nothing Sacred – A Song For Kirsty*
　　　　　　　　Decca UK 2002

Weaver, R.L.　　*Nothing Has Changed But You, Dear*
　　　　　　　　Jos. Morris Co, Philadelphia & N York 1910

Webbe, W.Y.　　*Only A Touch And Nothing More*
　　　　　　　　G. Schirmer, New York 1906

Welkel, C.B.　　*Nothing But A Rose*
　　　　　　　　J. Church & Co, Cincinnati 1904

Wells, G.　　　　*There's Nothing Like That About Me*
　　　　　　　　Francis, Day & Hunter, London 1901

West, Kanye.　　*Can't Tell Me Nothing*
　　　　　　　　(From the Album, ***Graduation***)
　　　　　　　　Roc-A-Fella, Def Jam 2007

Westthuizen, H.
　　　　　　　　Be Ye Careful For Nothing
　　　　　　　　Music 70, Fort Lauderdale,
　　　　　　　　Florida 1982

Whitaker, J.　　　*Nothing Like Pleasure*
　　　　　　　　Preston & Son, London 1795

Williams, C.L.　　*Judge Nothing Before The Time*
　　　　　　　　Novello & Co,
　　　　　　　　London 1889

Williams, R.V.　*Is It Nothing To You?*
　　　　　　　　J. Curwen & Sons, London 1950

　　　　　　　　Nothing Is Here For Tears
　　　　　　　　Oxford University Press, London 1936

Winn, W.　　　　*"Nothing More"*
　　　　　　　　Charles Jefferys, London 1856

Wood, F.　　　　*That's Nothing*
　　　　　　　　Walsh, Holmes & Co, London 1913

Yancey, J. *Nothin' But The Blues – Vol.1*
 Black Sheep Music 2012

Zittel, C. *Nothing Bothers Me!*
 Maurice Shapiro,
 New York 1907

Zucca, M. *Nichavoi! Nothing Matters*
 J. Church & Co,
 Cincinnati 1921

A *Nothing*
 (From the Album, ***Hi-Fi Serious***)
 CD/DVD/MP3 2002

Allan, G. *Nothing On The Radio*
 MCA Nashville. CD/MP3 2004

All Time Low *Nothing Personal*
 Hopeless Records 2009. CD/MP3 2012

Amory, C.S. *Nothing Matters*
 J. Williams, London 1909

Anderson, S.J. *She Talks of Nothing Else But Trilby*
 K. Dehnhoff,
 New York 1895

Apocalyptica *Nothing Else Matters*
 (From the Album, ***Inquisition Symphony***)
 Mercury/Universal. MP3D 1998

Arctic Monkeys *You Know Nothing*
 (From the Album, ***Whatever People Says
 I Am, That's What I'm Not***)
 Domino Records, LP CD MP3 2006

Armstrong, C. *As If To Nothing*
 EMI/Astralworks CD/MP3D 2002

Ashford, N. *Ain't Nothing Like The Real Thing*
 IMP, London 1994

Ayer, N.D. *Nothing To Do But Love*
Harry Williams Music Co, New York 1913

Babylon A.D. *Nothing Sacred*
Arista Records CD/Audio Cassette 1992

Baker, R.M. *She Thinks Nothing Of It Now*
W. Witmark Sons, London 1903

Balfe, M.W. *There's Nothing So Perplexing*
Chappell, London 1846

Ball, J. *Much Ado About Nothing*
Hopgood & Crew, London 1884

Banerji, C. *Yes I Know This Is Nothing But Thy Love*
J. Curwen & Sons, London 1926

Barnett, J. *Friends – But Nothing More!*
Duff & Stewart, London 1875 (?}

Barrett, R. *Nothing Elsewhere*
UMP, S.I. 1987

Bassey, S. *You Ain't Heard Nothing Yet*
M. Alexander & T. Withers.
VHS Tape 1985

Batho, R.E. *Nothing But Dreams.*
The Dreamland Valse.
Hutchings & Romer, London 1889

Bayliss, T. *Next To Nothing*
Phylloscopus Publications,
Lancaster1998

Bedingfield, D.

 Nothing Hurts Like Love
UK 2004

Beethoven, L. *Life Is Nothing Without Money*
Novello & Co, London 1930

Being As An Ocean *Nothing, Save The Power They're Given*
Video US 2013

Beresford, L. *Nothing's Worth While But Dreams*
Durgin d'Lash Publications, Chicago 1909

Berger, R. *Tout Passé!... Nothing Lasts!*
Enoch & Sons, London 1902

Bergh, A. *It Was Nothing But A Rose*
G. Schirmer, New York 1915

Bett, S. *Nothing Is Here For Tears* (Anthem)
Oxford University Press, London 1930

Big Star *Nothing Can Hurt Me*
Oakland 2012 DVD/MP3 2015

Blanke-Belcher, H. *There Is Nothing In The World Like Love*
Jerome H. Remick & Co,
Detroit & New York, 1908

Bowie, D. *Nothing Has Changed*
Parlaphone/Columbia CD/MP3 2014

Boyden, G.L. *There'll Be Nothing Too Good ForThe Boys*
G.L. Boyden, Boston 1918

Braham, P. *Nothing In It!*
E. Ascherberg & Co, London 1903

Brahe, M.H. *Nothing To Say*
Enoch & Sons, London 1919

Brahms, J. *Let Nothing Ever Grieve Thee*
C.F. Peters Corporation, New York 1956

Bratton, J.W. *I'm Nothing To You Now*
M.Wittmark & Sons, NY & Chicago 1898

Braun, C. *Nothing So Bright*
Lublin & Co, London 1907

Brentnall, E. *Life Hath Nothing That's Eternal*
 Leonard & Co, London 1904

Brockman, J. *I'd Rather Be A Not-Know Nothing ,*
 Than A Would-Be Know It All
 M. Witmark & Sons, New York 1910

 Nothing
 M. Witmark & Sons, New York 1910

Brown, J. *I Don't Want Nobody To Give Me Nothing;*
 Open Up The Door I'll Get It Myself Part 2
 From the Album, **Sex Machine**
 (King Label) US 1970

Burleigh, H.T. *It Was Nothing But A Rose*
 W. Maxwell Music Co, New York 1905

Burt, B.H. *He's Got Nothing On Me*
 Jerome H. Remick, Detroit & N York 1907

Buzzi-Peccia, A.
 Nothing In The World Is Single
 T. Presser, Philadelphia 1924

Carey, H. *How Brimful of Nothings The Life of a Beau*
 London (1940?)

Cass, R. *Nothing's Impossible* – From the Film,
 The Young Ones,Dir. S. J. Furie UK 1961

Christie, G. *There's Nothing Else In Life Like Love,*
 Love, Love!
 W. Witmark & Sons, New York 1909

Clark, M. *Nothing Comes Between Me (And My*
 Saviour)
 Elma & Carl's Music Pubs,Detroit 1964

Clarke, J. & Walker, B.
 Nothing Can Bring Back The Hour
 CD/MP3D 2014

Cobb, G.F.	*Nothing Else To Do* Mathias & Strickland, London 1893
Cohan, G.M.	*Nothing's Too Good For My Girl* G.L. Spaulding, New York 1897
Cohen, F.P.	*Dreams, Dreams, Nothing But Dreams* Howard A. Hill, Chicago 1903
Colles, A.	*Nothing* C. Jefferys, London 1888
Collins, C.	*Start Out With Nothing In Your Pocket* Francis, Day and Hunter, London 1911
Corney, A.	*There's Nothing In It* Hapgood & Crew, London 1887
Cowan, G.M.	*Nothing New Beneath The Sun* F.A. Mills, New York 1901
Coward, N.	*Nothing Can Last Forever* Chappell & Co, London 1950
Cowen, F. H.	*Ask Nothing More* J. Williams, London 1894
Crist, L.	*Nothing To Do* A. Fischer, New York 1916
Croce, G.	*O Vos Omnes (It Is Nothing, All of You* *Who Pass Me By)* G. Schirmer, New York 1966
Crosby, B.	*We're Busy Doing Nothing* (From the Film, **A Connecticut Yankee in** **King Arthur's Court** – Paramount 1949)
Dauphin, W.	*"But Then That's Nothing"* Hamilton S. Gordon, New York 1896

De St Johnstone, J.
>*Nothing To Do but Laugh*
>Associated Song Writers,
>Lansing Michigan 1914

De Sylva, B.G.
>*You Ain't Heard Nothing Yet*
>J.H. Remick & Co,
>New York 1919

Diamond, N. *Nothing But A Heartache*
(From the Album, **Melody Road**)
2014

Dick, C. *Much Ado About Nothing*
Enoch & Sons, London 1884

Dickson, B. *Nothing's Gonna Change My World: The*
Songs of Lennon, McCartney & Harrison
CD 2006

Dire Straits *Money for Nothing* (Album Version)
MP3D 2014

Dixon, A. *The Boy Does Nothing*
(From the Album, **The Aleisha Show**)
Asylum, Atlantic UK 2008

Dixon, R.W. *Nothing That Lives Can Bloom*
London 1854

Drake *Nothing Was The Same*
OVO, Aspire
CD/MP3D 2014

Druce, M. *It Was Nothing But A Rose*
S. Lucas, Weber & Co,
London 1887

Dyer, A.D. *Nothing Between*
Novello, Ewer & Co,
London/N. York 1891

Dylan, B.	*Nothing Was Delivered* (Bootleg Album, **Great White Wonder** 1961)
	Nothing You Can Say R & S Records 2000
	Too Much of Nothing (Bootleg Album, **Great White Wonder** 1961)
Edwards, G.	*I'm Good For Nothing Else But You* Shapiro, Bernstein & Co, New York 1915
Ellis, G.	*Nothing and Everything* Reynolds & Co, London 1925
Embrace	*Out of Nothing* International Music Publications, London 2005
Everard, G.	*It's Nothing To Do With You* Francis, Day & Hunter, London 1898
Farrell & Carver	*Let Nothing Trouble You* Herald Records CD 2008
Ferguson, B.	*Let Nothing Disturb Thee* Anglo-American Music Publishers, S.I. 1998
Ferguson, R.	*Nothing's Real But Love* (From the Album, **Heaven**) Syco, RCA, Columbia 2011
Fightstar	*We Apologise For Nothing* (From the Album, **One Day Son, This Will Be All Yours**) 2007
Fisher Music	*Nothing Stops Another Day* (From the Album, **Musical Theatre & Audition Backing Tracks, Vol.2**) 2012

Fitzgerald, E. *All Over Nothing At All*
MP3D 2013

Do Nothin' Till You Hear From Me
Verve Records 1956

I Ain't Got Nothing But The Blues
(From the Album, ***Ella Fitzgerald Sings***
The Duke Ellington Songbook 1958)

Foley, C. *If You've Got Nothing On Tonight*
Chas. Sheard & Co.
London 1917

Fontaine, E. *Nothin' Shakin*
London Records 1958

Foo Fighters *There Is Nothing Left To Lose*
RCA Records , November 1999

Something From Nothing
(From the Album, ***Sonic Highways***)
HBO MP3 2014

Formenti, M. *Nothing Is Real*
CD MP3 2007

Foster, M.B. *Is It Nothing To You?*
Novello & Co,
London 1897

Foster, S.C. *Nothing But A Plain Old Soldier*
New York 1862

Fotheringay *Nothing More – The Collected Fotheringay*
CD DVD Box Set 2015

Foxworthy, L. *Nothing Like A Broken Heart*
1980

Freemasons *Nothing But A Heartache*
(From The Album, ***Shakedown***) 2007

Furth, S.J.	*Nothing Like That In Our Family* M. Witmark & Sons, New York 1906
Galbraith, A.C.	*Nothing New* Weekes & Co, London 1905
Gensler, L.E.	*There's Nothing Like A College Education* (From the Film, **Old Man Rhythm** Directed by E. Ludwig, USA 1935)
German, E.	*Overture to **Much Ado About Nothing*** Novello & Co Lt, 1898
Gershwin, G.	*I Got Plenty of Nothing* Broadbent & Dunn, London 1990 *There Is Nothing Too Good For You* Chappell & Co, London 1944
Gilbert	*There's Nothing Like It* Decca 1964
Gillespie, A.	*Though She's Nothing To The World,* *She's All the World To Me* M. Witmark & Sons, Chicago & N York 1900
Godfrey, F.	*There'll Be Nothing But Boys In Kakhi* *By The Seaside* B. Feldman & Co, London 1915
Golden, G.F.	*Friends If Nothing More* Wills Woodward & Co, London 1891
Goodwin, J.	*Nothing's Too Good For The Irish* Frank Tousey's Publishing House, New York & London 1894
Gorrie, A., Stuart, H. & Ball, R.	*Nothing You Can Do* 1975

Gottler, A. *Nothing More Or Nothing Less*
 C. 12973 1933

Gouldman, G. *Nothing Ever Stay The Same*
 1969

Grainer, R. *Nothing But The Best*
 From the film, **Nothing But The Best**,
 Directed by C. Donner UK 1964

Green, A. *Nothing Compares To You*
 ITunes July 2009

 Nothing Impossible With Love
 ITunes April 2011

 Nothing Takes The Place of You
 (From the Album, ***Have A Good Time***)
 Hi Records 1976

Greene, B. *Nothing But The Blood*
 *(From the Album, **Simple Praise**)*
 Gaither Music Group,1996

Greene, M. *There's Nothing Like A Mother's Love*
 Daly, Boston 1911

Greenfield, H. & Mann, B.
 Nothing Is Impossible
 EMI Music 1961

Greenfield, H. & Sedaka, N.
 Nothing Less Than Forever
 EMI Music 1961

Gregorian *Nothing Else Matters*
 (From the Album, ***Masters of Chant***)
 Edel America Records 1999

Hadden, F.R. *Nothing's Ever Quite Like This*
 Carl Fischer, New York 1952

(C) ARTICLES &
CONFERENCE PAPERS

Bispham, J.
"Music" Means Nothing If We Don't Know What It Means
Journal of Human Evolution,
Vol.50 No.5, 587-593
Elsevier Science B.V. Amsterdam 2006

Black-Branch, J.L.
Being Over Nothingness: The Right To Life Under The Human Rights Act
European Law Review,
Vol. 26, Supp, 22-41
Sweet & Maxwell 2001

Blackford, A.
FINISH LINE: A Dog's Life – Nothing Is Sacred When You're Trying To Wriggle Out Of A Race
Runner's World, Vol. 11 Part 3, 142
Rodale Press 2003

FINISH LINE: It Ain't Nothing But A Hound Jog – The 'World's Fittest Dog' Laments The Incompetency of Its Owner
Runner's World, Vol. 11 Part 4, 150-51
Rodale Press 2003

Bledow, R. Et al
Extending and Refining The Dialectic Perspective on Innovation: There IsNothing As Practical As A Good Theory; Nothing As Theoretical As Good Practice
Industrial & Organisational Psychology:
Perspectives on Science & Practice,
Vol.2, No.3, 363-373
Blackwell Publishing Ltd 2009

Boggs, G.L.
Nothing Is More Important Than Thinking Dialectically
The New Centennial Review,
Vol.6, No.2, 1-6
Michigan State University Press 2006

Bondre, N. *European Adventures Did Nothing For
 The People of Egypt*
 Nature,
 Vol.451, No7, 768
 Nature Publishing Group 2008

Bordo, V. *Nothing Perks Up An Audience Like
 An Exciting Concert March*
 Instrumentalist,
 Vol. 54, Part 12, 17-24
 Instrumentalist Company 2000

Bouman, O. *Doing (Almost) Nothing Is (Almost)
 All Right*
 Volume, No.2, 3-4
 2005

Bowden, C. *Learning Nothing, Forgetting Nothing:
 OnThe Trail of Carl Lumholtz*
 Journal of The South-West,
 Vol.49, No.3, 357-368
 University of Arizona Press 2007

Bowie, A. *Simon Critchley,* **Very Little, Almost
 Nothing: Death, Philosophy, Literature**
 Radical Philosophy,
 Issue 90, 45-46
 RP Group 1998

Bowman, D. *GCSE Analysis: Sting's 5 Songs from
 'Nothing Like The Sun' (Part2)*
 Music Teacher,
 Vol.78 No.9. 37-43
 Rhinegold Publishing Ltd 1999

Bradt, T. *"Much To Gain & Nothing To Lose":
 Implications of The History of The
 Declamatory Judgement for The (b) (2)
 Class Action*
 Arkansas Law Review,
 Vol.58, No.4, 767-832
 ALR 2006

Brann, E. *The Ways of Naysaying:*
 No, Not, Nothing & Nonbeing
 Philosophy In Review,Vol.21, Part 6, 402-3
 PIR 2001

Brant-Zawadzki, M. *Being & Nothingness*
 Journal of The American College of
 Radiology, Vol. 10, No. 1, 4-5
 Elsevier Science BV Amsterdam 2013

Brass, T. *Book Review: Intern Nation – **How To***
 Earn Nothing & Learn Little in The
 ***Brave New Economy** by Ross Perlin*
 Capital & Class, Bulletin of The Conference
 Of Socialist Economists,
 Vol.36, No.2, 351-353
 Sage Publications 2012

Breazeale, D *Paul Franks, **All or Nothing: Systematicity,***
 Transcendental Arguments, and Skepticism
 In German Idealism
 Journal of The History of Philosophy,
 Vol.45, No4, 665-66
 The History of Philosophy, Inc 2007

Brener, J. *Bean Curd & Nothingness:*
 Cai Guo-Qiang Admires Charwei Tsai's
 Inscriptions on Lemons, Trees & Rotting
 Slabs of Tofu As Meditations On
 The Ephemerality of Life
 Art News, Vol. 105, No. 10, 156-157
 AN Subscription Service 2006

Bridges, R. *Who Says Nothing Happens In My*
 Backyard?
 Radio User, Vol.2, No.7, 73
 PW Publishing Ltd 2007

Brill, S. *Does It Matter That Nothing We Do Will*
 Matter In A Million Years?
 Dialogue, Vol.46, No.1, 3-26
 Canadian Philosophical Association 2007

Bronstein, C. *On The Excess of Nothing: Discussion of*
 J.B.Pontalis', 'No, Twice No'
 International Journal of Psychoanalysis,
 Vol.95, No.3, 563-71
 Blackwell Publishing Ltd 2014

Buchan, B.A. *Situated Consciousness or Consciousness*
 Of Situation?
 Autonomy & Antagonism In
 Jean-Paul Sarter's, **Being & Nothingness**
 History of European Ideas,
 Vol. 22, No. 3, 193-216
 Pergamon Press 1996

Burgess, M. & Enzle, M.E.
 The Social Psychological Power of
 Photography:
 Can The Image Freezing
 Machine Make Something Out of Nothing?
 European Journal of Social Psychology,
 Vol.30, Part 5, 613-630
 John Wiley & Sons Ltd 2000

Byatt, A.S. *Spotlight Out of Nothingness:*
 On The Gothic Imagination of Alan Stocker
 Modern Painters,
 Vol. 11, Issue 4, 62-65
 Fine Art Journals 1998

Cahoone, L. *Arguments From Nothing:*
 God & Quantum Cosmology
 Zygon,
 Vol.44, No.4, 777-796
 Blackwell Publishing Ltd

Calcagno, M. *Signifying Nothing:*
 On The Aesthetics of
 Pure Voice in Early Venetian Opera
 The Journal of Musicology,
 Vol.20 No.4 461-49
 JM 2003

Calcut, T.D.
Counting For Nothing? The Importance of Quantifying Social Risks in Major Capital Projects
SPE: America's E&P Health, Safety, Security & Environmental Conference,
O, 123-128
Houston, Texas 2011

Cameron, R.P.
Much Ado About Nothing: A Study of Metaphysical Nihilism
Erkenntnis, Vol.64, No.2, 193-222
Springer Science Business Media 2006

Cannon, B.
Nothingness As The Ground For Change: Gestalt Therapy & Existentialist Psychoanalysis
Existential Analysis, Vol. 20, No. 2, 192-210
The Society For Existential Analysis 2009

Carlisle, B.
I'm Trying To Think But Nothing Happened
Proceedings – IEEE International Conference on Robotics & Automation,
No.1, 19
IEEE 1995

Carrion, M.
Spain's Young People Turn Indignant: They Are Seeking Nothing Less Than A Profound Social Transformation
The Progressive,
Vol.75, No8, 30-32
The Progressive, Inc 2011

Carson, J. Et al
Burn-Out In Mental Health Nurses: Much Ado About Nothing?
Stress Medicine,
Vol. 15, No. 2, 127-134
John Wiley & Sons 1999

Carson, U.
Nothing But Snake-Oil?
Explore: The Journal of Science & Healing,
Vol. 3, No. 6, 623-625
Elsevier Science BV Amsterdam 2007

Carville, J. *Signifying Nothing:*
 Translating Photography
 In A Digital Culture
 Circa: Contemporary Art Journal,
 Issue 98, Supp 23.2
 CIRCA 2001

Casal, T. *"I Did Not Know What To Think, So*
 I SaidNothing". Narrative Politics
 In Castle Rackrent
 Costerus: International Association For The
 Study of Irish Literture.
 Back To The Present, Forward To The Past:
 Irish Writing & History Since 1798,
 University of Limerick
 1998, July, 69-82
 Rodopi, Amsterdam /New York 2006

Casati, C.M. *Quantity Is Nothing To Boast About*
 L'Arca, No.245, 1
 Arca Edizioni Spa 2009

Catania, S. *"Darkness Rumbling":*
 Kozintsev's **Karol Lier**
 & The Visual Acoustics of Nothing
 Literature Film Quarterly,
 Vol. 36, No 2 85-93
 Salisbury State College 2008

Cavill, M. *Mindfulness, Nothing Special*
 Existential Analysis:
 A Journal of The Society For Existential
 Analysis,
 Vol. 21, No. 1, 37-40
 SEA 2010

Chai, D. *Nothingness & The Clearing:*
 Heidegger, Davison &
 The Quest For Primal Clarity
 The Review of Metaphysics,
 Vol. 67, No. 3, Issue 267, 583-602
 Catholic University of America 2014

Chakravorty, M. *Never Kill A Man Who Says Nothing:*
Things Fall Apart
& The Spoken Worlds Of African Fiction
Ariel: A Review of International Literature,
Vol.43, No.4, 11-48
The University of Calgary Press 2012

Chamberlain, R. *'A Nothing Which Counts':*
Empsonian Ambiguity,
The Subject
& Shakespeare's **Sonnet 1**
English,
Vol.51, Issue 200, 111-126
The Journal of The English Association
University of Leicester 2002

Chaohua, W. *Nothing To Lose But Their Power: A*
Communist Party that Venerates The
Market, not Marx
New Statesman,
No.4719/4720, 22-23
NS Ltd 2005

Chazelle, B. *The Security of Knowing Nothing*
Nature, Vol. 446, No.7, 992-993
Nature Publishing Group 2007

Chekuri, C., Khanna, S. & Shepperd, F.B.
The All-or-Nothing Multicommodity Flow
Problem
SIAM Journal on Computing,
Vol.42, No.4, 1467-1493
SIAM 2013

Chen-Morris, R. & Gal, O.
"The Quality of Nothing" – Shakespearean
Mirrors and Kepler's Visual Economy of
Science
International Archives of The History of
Ideas,
Vol. 208, 98-118
Kluwer Academic Publishers 2013

Chessick, R.D.

 Nothingness, Meaninglessness, Chaos
 & The "Black Hole" Revisited
 The Journal of The American Academy
 Of Psychoanalysis,
 Vol. 23, No. 4, 581-602
 Guildford Press 1995

Chia, R. & Tsoukas, H.

 Everything Flows and Nothing Abides!
 Towards a "Rhizomic" Model of
 Organisational Change, Transformation and
 Action
 Process Studies,
 Vol.32, Part 2, 196-224
 Centre for Process Studies 2003

Chodankar, H. *Are Nurses Nothing More Than Doctor's*
 Helpers?
 Nursing Journal of India,
 No.102, No.9, 212-213
 Trained Nurses Association Of India 2011

Christensen, C.M.

 How Do We Transform Our Schools? Use
 Technologies That Compete Against Nothing
 Education Next: A Journal of Opinion &
 Research,
 Vol.8, No.3, 12-19
 Leland Stanford Junior University. 2008

Christiana, G. *Comforting Thoughts About Death*
 That Have Nothing To Do With God
 The Skeptikal Inquirer, Vol. 29, No.2, 50-51
 2005

Clancy, P. *There's Nothing Like A Dose of Poll Nerves*
 & Self-Preservation Fears To Generate
 Clear Thinking Among Politicians
 The Australian & New Zealand Wine
 Industry Journal, Vol.19, No.3, 4
 Winetitles 2004

Clark, S. & Fetzer, J.H.
 Nothing Without Mind
 Advances in Consciousness Research
 Vol.34, 139-60
 John Benjamin Publishing Co 2012

Clurman, D.
 Nothing Behind Closets
 Journal of Bisexuality, Vol.2, Part 4, 149-50
 Harrington Park Press 2001

Cohen, N.
 Nothing Frustrates Professor Steve Jones
 More Than Bad Science
 New Statesman, No.4850, 36-38
 NS Ltd 2007

Cohen, R.
 To Love God For Nothing:
 Levinas & Spinoza
 Graduate Faculty Philosophy Journal,
 Vol. 20/21, No. 2/1, 339-354
 GFPJ 1998

Cohen, R.D.
 Lawrence Cohn, Ed., **Nothing But The**
 Blues: The Music & The Musicians
 American Music, Vol. 13 No.2, 224
 University of Illinois Press, 1995

Cole, K. C.
 Nothing Gets Strung Out Strangely
 Beautiful Or Nothing Short of Bizarre:
 String Theory & Its 11 Dimensions Of
 Space-Time Could Hold The Key To
 Describing How The Universe Works
 Astronomy, Vol. 29, Part 11, 46-49
 Kalmbach Publishing Co 2001

Coleman, M.C.
 Nothing Compares To Comparison:
 Reflections on The Social Issue of
 The American Indan Quarterly, *Dedicated*
 To "Writing About American Indians"
 The American Indian Quarterly: A Journal of
 Anthropology, History & Literature
 Vol.22, No.1/2, 116-24
 University of Nebraska Press 1998

Collins, H.M. *Lead Into Gold: The Science of Finding*
 Nothing
 Studies in History & Philosophy of Science
 Vol.34, No4, 661-691
 Elsevier Science B.V. Amsterdam 2003

Connor, S. *Air: Next-To-Nothing*
 Tate etc, 12, 82-93
 Tate Publishing 2008

Conte, J. *Joseph Dewey – Beyond Grief & Nothing:*
 A Reading of Don Del Lillo
 Modernism/Modernity,
 Vol.15, No.3, 585-586
 The John Hopkins University Press 2008

Contini-Moravia, E. Et al
 The Difference Between Zero & Nothing:
 Swahili Noun Class Prefixes 5 & 9/10
 Studies in Functional & Structural
 Linguistics,
 Vol.57, 211-222
 John Benjamins 2006

Cook.A. *Staging Nothing:*
 Hamlet*& CognitiveScience*
 Sub-stance, Issue 110, 83-89
 University of Wisconsin Press 2006

Cook, I. *'Nothing Can Ever Be The Cause of "Us" &*
 "Them" Again':
 Exploring The Politics of Difference
 Through Border Pedagogy
 & Student Journal Writing
 Journal of Geography in Higher Education,
 Vol.24, Part 1, 13-28
 Carfax Publishing Co L 2000

Cornia, P.B. *Nothing To Cough At*
 The New England Journal of Medicine,
 Vol.357, No.14, 1432-38
 Massachusetts Medical Society 2007

Covey, S.M.R.	*Nothing Is As Fast As The Speed of Trust:*
Succeeding in Today's Knowledge-Based
Economy Hangs On Trust
Textile Rental, Vol.91, No.12, 26-27
TR Services 2008

Covitz, H.H.	*Paul Verhaeghe,* **New Studies of Old**
Villains: A Radical Reconstruction of
The Oedipus Complex; *Dany Nobus &*
Malcolm Quinn, **Knowing Nothing,**
Staying Stupid: Elements For A
Psychoanalytic Epistemology
American Journal of Psychoanalysis,
Vol. 72, No. 3, 307-314
Palgrave-Macmillan 2012

Cravino, J.,Lederman, D. & Olarreaga, D.
Substitution Between Foreign Capital in
China, India, The Rest of The World &
Latin America: Much Ado About Nothing?
Journal of Economic Integration,
Vol.23, Part 4, 953-976
Centre For International Economics
Sejone Institution 2008

Creekmore, C.	*Science of The Inconceivable: Einstein's*
Calculations On The Energy-Gorged
Nothingness of Outer Space
The Humanist, Vol. 73, No. 4, 18-21
AHA 2013

Crespo, A. & Stewart, S.J.
On Nothingness
The New Orleans Review,
Vol. 33, No. 2, 39
Loyola University 2007

Csink, A.K. & Heinkoff, S.
Something From Nothing: The Evolution
Of Utility of Satellite Repeats
Trends in Genetics, Vol.14, No.5, 200-204
1998

Cummings, J. & Mello, M.
 'We Can Put Our Heads Down &
 Do Nothing – Or We Can Take Action'
 Nursing Times, Vol.107, No.22, 7
 Emap Inform 2011

Curtin, L.L. *Job Security: Is Nothing Sacred Anymore?*
 Nursing Management, Vol.26, No.7, 7
 SN Publications 1995

Daalder, J. *The 'Pre-History' of Beatrice & Benedick in*
 Much Ado About Nothing
 English Studies, A Journal of English Letters
 & Philology, Vol.85, No.6, 520-527
 Swets & Zeitlinger 2004

Daffy, C. *Why Do We Keep Rewarding The Wrong*
 Customer? Too Often Being A Good, Loyal
 Customer Counts For Too Little Or Nothing
 Consumer Services Management,
 Issue 10, 56-57
 Ways With Words 1996

Daigle, C. *Being & Nothingness*
 Philosophy Now, Issue 53, 14-15
 PN 2005

Dalrymple, T. *Famous For Nothing*
 British Medical Journal, No.7781, 1055
 BMA 2010

Dandaneau, S.P. & Dudsworth, R.M.
 Being (George Ritzer) & Nothingness:
 An Interview
 The American Sociologist,
 Vol. 37, No. 4, 84-96
 Transaction Periodicals Consortium 2006

Daniels, J. *Wanting Nothing: Limitation & Production*
 In The Economy of Desire
 New Blackfriars, Vol.90, No.1025, 90-107
 Blackwell Publishing Ltd 2009

Darwent, C. *The Approach In Work Of A New Generation*
 Of Photographers Amounts To Nothing Less
 Than A Crise Photographique
 Art Review: International Art & Style,
 October, 68-71
 Art Review Magazine 2003

Davis, A. *Mathew Hart:*
 Nations of Nothing But Poetry:
 Modernism, Transnationalism,
 &Synthetic Vernacular Writing
 The Review of English Studies,
 Vol.62, No.257, 832-834
 Oxford University Press 2011

Davis, M. *Making Something From Nothing:*
 On Plato's, ***Hipparchus***
 The Review of Politics,
 Vol.68, No.4, 547-63
 Cambridge University Press

Debrix, F. & Barder, A.D.
 Nothing To Fear But Fear:
 Governmentality & The Biopolitical
 Production of Terror
 International Political Sociology,
 Vol. 3, No. 4, 398-414
 Blackwell Publishing Ltd 2009

Deckard, S. *"Nothing is Truly Hidden": Visibility,*
 Aesthetics & Yasmina Khadra's Detective
 Fiction
 Journal of Postcolonial Writing,
 Vol.49, No.1, 74-86
 Taylor & Francis 2013

De Grand, A. *'To Learn Nothing & To Forget Nothing':*
 National Socialism & The Experience of
 Exile Politics 1935-1945
 Contemporary European History,
 Vol.14, Part 4, 539-558
 Cambridge University Press 2005

De La Bellacasa, M.P.
Nothing Comes Without Its World:
Thinking With Care
Sociological Review,
Vol.60, No.2, 197-216
Blackwell Publishing 2012

De Moor, A. *Nothing Else To Think?*
On Meaning, Truth & Objectivity in Law
Oxford Journal of Legal Studies,
Vol.18, No.2, 345-62
Oxford University Press 1998

Dennis, V.S. *Nothing To Do With Me*
Tolley's Insolvency Law & Practice,
Vol.16, Part 3, 83-85
Tolley Publishing Co Ltd 2000

Deutsch, D. & Ekert, A.
Beyond The Quantum Horizon:
Once Viewed As Implying That
Nothing Can Be Known
For Certain,
Quantum Theory
Is Now Expanding
The Power of Computers
& The Vistas of The Mind
Scientific American,
Vol.307, No.3, 84-89
CDS Communications Data Services 2012

Devagupta, R. *"Nothingness"/Hindu*
Parabola,
Vol. 25, Part 2, 59-70
Society For The Study of Myth & Tradition
2000

Devolder, K. *Killing Discarded Embryos*
& The Nothing-is-Lost Principle
Journal of Applied Philosophy,
Vol.30, Issue 4, 289
John Wiley & Sons, Inc 2013

Ding, K. & Slaughter, J.R.
"Searching After The Splendid Nothing":
Gothic Epistemology & The Rise of
Fictionality
ELH: A Journal of English Literary History,
Vol.80, No.2, 543-574
The John Hopkins University Press 2013

Dinnie, K.
Innocent: Building A Brand From Nothing
*But Fruit/**Tiger Beer**: Distinctly Asian,*
Unmistakably World Class
Journal of Brand Management,
Vol.17, No.6, 461-464
Palgrave Macmillan 2010

Dixon, M.J.C. & Hopkins, D.
"Blackbirds Rose From A Field..." –
Production, Structure and Obedience in
*John Cage's,**Lecture on Nothing***
Avant-garde Critical Studies, No.20 389-402
Editions RODOPI BV 2006

Dobranski, S.B.
Children Of The Mind: Miscarried
*Narratives in **Much Ado About Nothing***
Studies in English Literature1500-1900,
Vol.38, No.2, 233-250
Rice University 1998

Donovan, T.
Foreign Jurisprudence – To Cite or Not To
Cite: Is That The Question or Is It Much Ado
About Nothing?
Capital University Law Review,
Vol. 35, No.3, 762-786
Capital University Law School 2007

Dorn, G.W. & Simpson, P.C.
Nix, Nought, Nothing:
Fairy Tale
Or Real Deal
Journal of Molecular & Cellular Cardiology,
Vol.151, No.4, 497-500
Elsevier Science B.V. Amsterdam 2011

Downing, P.E. Et al

 Bodies Capture Attention When Nothing Is
 Expended
 Cognition: International Journal of Cognitive
 Science,
 Vol.93, No.1, B27-B38
 Elsevier Science B.V. Amsterdam 2004

Doyle, T. *Daniel J. Solove, **Nothing To Hide: The***
 False Trade-off Between Privacy &Security
 Journal of Value Inquiry,
 Vol. 46, No. 1, 107-112
 Springer Science & Business Media 2012

Dubbelboer, M.

 'Nothing Ruins Writers Like Journalism':
 Colette, The Press & Belle Époque
 Literary Life
 French Cultural Studies,
 Vol. 26, Issue 1, 32
 Sage 2015

Dumitru, M. & Kroon, F.

 What To Say When There Is Nothing To Talk
 About
 Critica: Revisita Hispanoamericana de
 Filosofia,No.120, 97-109
 Universidad NacionalAutonoma de Mexico
 2008

Dvorakova, A.

 Laughing At Nothing – Humour As A
 Response To Nihilism
 The British Journal of Aesthetics,
 Vol.45, No.1, 106-8
 Oxford University Press 2005

Dyer, R. *"There's Nothing I Can Do! Nothing!" –*
 Femininity, Seriality & Whiteness in
 The Jewel in The Crown
 Screen, Vol. 37, No. 3, 225-39
 Oxford University Press, 1996

Eason, R.E. *The Whole Truth & Nothing But The Truth*
Human Studies: A Journal For Philosophy &
The Social Sciences, Vol. 28, No. 1, 95-100
Springer 2005

Ebrahim, S. *Social Capital: Everything or Nothing?*
International Journal of Epidemiology,
Vol.33, No.4, 627
Oxford University Press 2004

Eder, A.B. & Dignath, D.
I Like To Get Nothing: Implicit & Explicit
Evaluation of Avoided Negative Outcomes
Journal of Experimental Psychology: Animal
Learning & Cognition,
Vol.40, No.1, 55-62
American Psychological Association 2014

Efird, D. & Stoneham, T.
Combinatorialism & The Possibility of
Nothing
Australasian Journal of Philosophy,
Vol. 84, No. 2, 269-280
Taylor & Francis Group 2006

Elden, S. *To Say Nothing of God:*
Heidegger's Holy Atheism
Heythrop Journal,Vol. 45, No. 3, 344-348
Blackwell Publishing Ltd 2004

Elkins, J. *Why Nothing Can Be Accomplished*
In Painting, And Why It Is Important
To Keep Trying
Circa: Contemporary Art Jnl, No. 109, 38-41
CIRCA 2004

Ellonen-Jequier, M. *Analysis of The Creation of 'Emptiness',*
Of 'Nothingness', in Certain Types of
Psychosis
International Journal of Psychoanalysis,
Vol. 90, No. 4, 843-866
Institute of Psychoanalysis 2009

Emanuel, R. A-Void: An Exploration of Defences
Against Sensing Nothingness
<u>Educational Therapy & Therapy Teaching</u>,
Issue 12, 7-26
Caspari Foundation, London 2003

Endress, A.D. *Something From (Almost) Nothing:*
Build-up Of Object Memory From
Forgettable Single Fixations
<u>Attention, Perception & Psychophysics</u>,
Vol.76, No.8, 2413-2423
Psychonomic Society 2014

Epelboim, J., Booth, J.R. & Steinman, R.M.
Much Ado About Nothing:
The Place of Space In Text
<u>Vision Research</u>, Vol..36, No.3, 466-70
Pergamon Press 1996

Erdinast-Vulcan, D.
"Signifying Nothing": Conrad's Idiots
& The Anxiety of Modernism
<u>Studies in Short Fiction</u>,
Vol.33, No.2,185-96
Newberry College 1996

Erickson, J. *Is Nothing To Be Done?*
<u>Modern Drama</u>, Vol. 50 No.2, 258-75
University of Toronto Press, 2007

Evans, C. ***Nothing In Itself: Complexions of Fashion***
By Herbert Blau
<u>Fashion Theory: The Journal of Dress,</u>
<u>Body & Culture</u>,
Vol.6 Part 2, 243-246
BERG 2002

Evans, K.L. *Why The **Tractatus**,*
*Like **The Old Testament**,*
Is 'Nothing But A Book'
<u>Philosophy</u>, Vol. 88, No2, 267-298
Cambridge University Press 2013

Evans, W.G. *Platform:*
W.G. Sebald Was Nothing But A Charlatan
New Statesman,
Vol.16, No321, 54-55
NS Ltd 2003

Falgas, J. & Taylor, M.
At Top Speed Towards Absolute
Nothingness: Dali & The Nouveau Realistes
Dali Renaissance – New Perspectives On His
Art & Life After 1940, O,112-127
New Haven, Connecticut April 2005
Yale University Press 2005 2008

Fan, M. *The Significance of Xuwu (Nothingness)*
In Chinese Aesthetics
Frontiers of Philosophy in China: Selected
Publications From Chinese Universities,
Vol. 5, No. 4, 560-574
Springer 2010

Farrell, L. *Good Doctors Doing Nothing*
British Medical Jrnl,
Vol.318, No.7198, 1633
BMA 1999

Feldman, J.M. *Useful Posturing:* **The Chicago Beyond**
Open Skies Conference *Accomplished*
Nothing of Significance, But Perhaps Some
Wheels Were Set In Motion
Air Transport World, Vol.37, Part 2, 67-74
Penton Publishing 2000

Felski, R. *Nothing To Declare: Identity, Shame, &*
TheLower Middle Class
The Modern Language Association of
America, Vol.115, Part 1, 33-45
MLAA 2000

Ferraz, S. *The Reader Ruminating On Nothing*
Semina-Londrina, Vo.17, No.3, 313-320
Universidade Estadual de Londrina 1996

Fertig, M. & Tamm, M.
Always Poor or Never Poor
& Nothing In Between?
Duration of Child Poverty
In Germany
German Economic Review,
Vol.11, No.2, 150-68
Blackwell Publishing Ltd 2010

Fickweiler, F., Keers, J.C. & Schultz, W.C.
Sexual Health of Dutch Medical Students:
Nothing To Worry About
The Journal of Sexual Medicine,
Vol.8, No.9, 2450-60
Blackwell Publishing Ltd 2011

Finci, P. ***Being & Nothingness***
Synthesis Philosophica,
Vol. 12, No. 1, 283-294
The Croatian Philosophical Society 1997

Flath, C. *Writing About Nothing:*
*Chekov's, **Ariadne***
& The Narcissistic Narrator
Slavonic & East European Review,
Vol. 77, No.2, 223-239
W.S. Maney & Son Ltd 1999

Fontecave, M., Atta, M. & Mulliez, E.
S-adenosylmethionine:
Nothing Goes To Waste
Trends in Bio-Chemical Sciences.
Vol.29, No.5, 243-249
Elsevier Science B.V. Amsterdam 2004

Forty, A. *Being or Nothingness:*
Private Experience
& Public Architecture
In Post-War Britain
Architectural History,
Vol. 38, 25
SAHGB 1995

Franke, W. *Apophatic Paths:*
 Modern & ContemporaryPoetics
 & Aesthetics of Nothing
 Angelaki: Journal of The Theoretical
 Humanities,
 Vol. 17, No. 3, 7-16
 Taylor & Francis 2012

Freeman, R.R. *What To Do When Nothing Has Happened?*
 Process Safety Progress,
 Vol. 30, No.3, 204-211
 John Wiley & Sons, Ltd 2011

Frickel, S. *Absences: A Methodological Note About*
 Nothing, In Particular
 Social Epistemology,
 Vol.28, Issue 1, 86-95
 Taylor & Francis 2014

Friedman, K. *Freedom? Nothingness? Time?*
 ***Fluxus**& The Laboratory of Ideas*
 Theory, Culture & Society,
 Vol. 29, No. 7-8, 372-398
 Sage Publications 2012

Fukazawa, T. *How Can The Cochlear Amplifier Be*
 Realised By The Outer Hair Cells Which
 Have Nothing To Push Against?
 Hearing Research,
 Vol.172, No.1-2, 53-61
 Elsevier Science B.V. Amsterdam 2002

Gaitan, S.C. & Wixted, J.T.
 The Role of "Nothing" in Memory For
 Event Duration in Pigeons
 Animal Learing & Behaviour,
 Vol.28, Part 2, 147-161
 Psychonomic Society 2000

Galeano, E. *Nothingness, Or Venezuela*
 New Left Review, Issue 29, 26-28
 NLR Ltd 2004

Gallardo, A. & Figueras,
 Historical Epistemological Analysis In
 Mathematical Education:
 Negative Numbers & Nothingness
 Proceedings of The International Group For
 The Psychology of Mathematics Education
 O,1-17 Morelia Mexico July 2008
 CRASSN 2008

Gandossy, R. & Sonnefeld, J.
 'I See Nothing, I Hear Nothing': Culture,
 Corruption & Apathy
 International Journal of Disclosure &
 Governance,
 Vol.2, No.3, 228-243
 Henry Stewart Publications 2005

Ganssle, J. G. *Assume Nothing:*
 An Engineer's Duty is To Assume Nothing,
 Think of Everything, & Be Humble
 Embedded Systems Design,
 Vol.24, No.6, 33
 CMP Media LLC 2011

 Assume Nothing: Test Everything
 EDN, Vol.40, No.24, 171
 Cahners Publishing 1995

Garcha, A. *Conclusion: "Nothing Democratic":*
 Intelligence, Abstraction & Avant-garde
 Plotlessness
 Cambridge Studies in 19th Century
 Literature & Culture,
 Vol.67, 219-40
 Cambridge University Press 2009

Garcia, E.V. *Paul Franks, **All or Nothing: Systematicity,***
 Transcendental Arguments, & Skepticism
 In German Idealism
 The Philosophical Review,
 Vol. 117, No.2, 300-303
 Duke University Press 2008

Gearey, R. *Death of Home Rule (111): A Capital*
 Crime. A Man is Killed, A Defunct Police
 Force Does Almost Nothing & A
 Benumbed City Barely Notices
 The New Republic, Issue 4279, 12-13
 NR 1997

Gerber, R.J. Three Joseph Kossuth Installations: **Texts**
 (Waiting For -) **For Nothing**, Samuel
 Beckett, in **Play**; Tilted (Art as Idea as
 Idea) Nothing; and **"Ulysses,"** 18 Titles
 & Hours
 James Joyce Quarterly,
 Vol.47, No.4, 670-74
 University of Tulsa 2010

Ghamari-Tabrizi, S. *Feminine Substance in **Being & Nothingness***
 The American Imago: A Psychoanalytic
 Journal For The Arts & Sciences,
 Vol. 56, No. 2, 133-144
 The John Hopkins UP, Baltimore 1999

Gibbons, J. *The Value of Nothing*
 The New Law Journal, No.6987, 858
 Butterworth & Co 2001

Gini, A. *"Too Much To Say About Nothing"*
 *(Joseph C. Rost, **Leadership For The***
 ***Twenty-First Century**)*
 Business Ethics Quarterly,
 Vol. 5, No. 1, 143
 JSBE 1995

Gizzi, P. *"In Defense of Nothing"*
 Sub-stance, Issu 10, 117
 University of Wisconsin Press 2006

Globus, A., Raible, E. & Kaufman, A.E.
 Fourteen Ways To Say Nothing With
 Scientific Visualisation
 Computer, Vol.27, No.7, 86
 IEEE 1994

Glyptis, M. *The In-Season Athlete: Who Is The Strongest When It Means Nothing, And Who Is The Weakest When It Means Everything?*
Coach & Athletic Director, Vol78, No.5, 36-7
Scholastic Inc2008

Goldschmidt, T.
 Why Is There Something Rather Than Nothing? *By Bede Rundle*
Heythrop Journal,Vol. 52, No. 2, 307-308
Blackwell Publishing Ltd 2011

Goodwin, B. *"Nothing Is, But What Is Not":*
Utopias As Practical Political Philosophy
Critical Review of International Social & Political Philosophy, 3, No's 2/3, 9-24
2000

Gorelick, D. *Vacuums: More Than Nothing*
American Printer, April 56-57
Primedia Inc 2007

Gough, M.J. *"Her Filthy Feature Open Showne", in Ariosto, Spenser & **Much Ado About Nothing***
Studies in English Literature 1500-1900,
Vol.39, No.1, 41-68
Rice University 1999

Grant, R. *Not Enough, Or Thinking Degree Zero (Simon Critchley, **Very Little... Almost Nothing**)*
Inquiry: An Interdisciplinary Journal of Philosophy & The Social Sciences,
Vol. 41, No. 4, 477-496
Scandinavian University Press 1998

Graybill, M.S. *"Nothing Really Matters": Inauthenticity, Intertextuality, & Rock in **Wayne's World***
College English Association – Critic,
Vol. 66, No.2/3, 39-46
CEA Publications 2004

Greer, G. *Depths of Ignorance: You Brits Know*
 Nothing About Australian Art
 <u>Prospect,</u> Issue 212, 56
 Prospect Publishing Ltd

Greiner, R. *The Art of Knowing Your Own Nothingness*
 <u>ELH: A Journal of English Literary History</u>,
 Vol. 77, No. 4, 893-914
 The John Hopkins UP, Baltimore 2010

Gunnell, B. *Nothing To Sell But Their Bodies*
 <u>New Statesman,</u> Vol.133, No.4677, 32-33
 New Statesman Ltd 2004

Gutteridge, T. *RTS Fleming Lecture:*
 57 Channels & Nothing On
 <u>Television: The Journal of The Royal</u>
 <u>Television Society</u>, Vol.32, No.4, 6
 RTS 1995

Haas, R.B. *Quirk, Tom.* **Nothing Abstract:**
 Investigations In The Literary Imagination
 <u>Studies in The Novel</u>, Vol.35, Part 2, 283-4
 University of North Texas 2003

Hadighi, M. ***Nothing Less Than Literal: Architecture***
 After Minimalism
 <u>Journal of Architectural Education</u>,
 Vol. 59, No. 4, 83-84
 Elsevier 2006

Hall, K.L. *Double or Nothing: San Juan Shop Owners*
 Gamble on A Dream & A Win
 <u>Quick Printing</u>,
 Vol.21, No.3, 24-25
 PTN Publishing Co 1997

Hanley, R. *Much Ado About Nothing:*
 Critical RealismExamined
 <u>Philosophical Studies</u>,
 Vol. 15, No.2, 123-47
 Kuwer Academic Publishers 2003

Hardy, S.M. *Nothing Lasts Forever – Does It?*
Journal of Electronic Defence,
Vol.17, No.4, 37
Horizon House – Microwave Inc 1994

Harris, M.D. *Existence, Nothingness & The Quest For*
Being: Sartrean Existentialism &
Julie Cortazar's Early Short Fiction
Latin American Literary Review,
Vol. 37, No. 74, 5-25
LALR 2009

Harris, P. *Nothing – A User's Manual*
Sub-stance, Issue 110, 3-16
University of Wisconsin Press 2006

Hatfield, J. *Corporate Finance: Nothing Is Added As*
The Accountants Gatecrash The Capital
Raising Party Which Previously Admitted
Merchant Bankers Only
Chartered Accountant,
Issue 1092, 34-37
ICAS 1997

Haught, J.A. *Meaning & Nothingness*
Free Inquiry,
Vol. 22, Part 1, 36-37
The Council For Democratic & Secular
Humanism 2002

Havens, H. *"Nothing Can Come of Nothing":*
Systems of Exchange in Tate's,
King Lear
Restoration & 18th Century Theatre
Research,
Vol.26, No.1/2, 23-40
Loyola University, Chicago 2011

Hazanov, V. *The Fear of Doing Nothing*
Contemporary Psychoanalysis,
Vol.48, No.4, 512-32
W.A. White Institute 2012

Heath, S. "Nothing Is Too Good For Ordinary
 People"
 British Medical Journal, No. 7692, 444
 BMA 2009

Heinamaki, E. Nothing Distinguishes Us From God,
 Bataille, Mysticism & Divine Nothingness
 Angelaki: Journal of The Theoretical
 Humanities, Vol. 17, No. 3, 113-122
 Taylor & Francis 2012

Heisig, J.W. Nothing & Nowhere East & West
 The Hint of A Common Ground
 Angelaki: Journal of The Theoretical
 Humanities, Vol. 17, No. 3, 17-30
 Taylor & Francis 2012

Henkin, R.E. Nothing Is Certain But Change
 Applied Radiology, Vol.27, No.6, 5-6
 AR 1998

Henry, M. The Meaning of "Demonic Nothingness"
 Modern Age,
 Vol. 45, Part 3, 208-217
 The Intercollegiate Studies Institute 2003

Hilfer, A.C. "The Nothing That Is"; Representations
 Of Nature in American Writing
 Texas Studies in Literature & Language,
 Vol.54, No.2
 University of Texas Press 2012

Hodgson, J. There's A Whole Lot of Nothing Going On
 Bio/Technology,
 Vol.13, No.7, 714
 Macmillan Publishers Ltd 1995

Hodgson, J.& Tadros, V.
 How To Make A Terrorist Out Of Nothing
 The Modern Law Review,
 Vol.72, No.6, 984-998
 Blackwell Publishing Ltd 2009

Hoekstra, K.　　*Nothing To Declare?*
　　　　　　　　Hobbes & The Advocate of Injustice
　　　　　　　　Political Theory: An International Journal
　　　　　　　　Of Political Philosophy,
　　　　　　　　Vol. 27, No. 2, 230-235
　　　　　　　　Sage Periodical Press 1999

Hoffman, J.　　*Ride of a Lifetime: Nothing Can Compare*
　　　　　　　　To Actually Going Into Space
　　　　　　　　New Scientist, No.2620, 34-61
　　　　　　　　IPC Magazines Ltd 2007

Hoffmeister, P. & Rothberg, M.
　　　　　　　　Central Asian Gesamkunstwerk: The Rise
　　　　　　　　& Rise of The Turkmen in The Otherwise
　　　　　　　　Uncertain World of Carpet Collecting Seems
　　　　　　　　Assured After The Philadelphia Conference,
　　　　　　　　Where Nothing Was More Hotly Debated or
　　　　　　　　(Ecstatically) Appreciated
　　　　　　　　Hali: The International Journal of Oriental
　　　　　　　　Carpets & Textiles,
　　　　　　　　Issue 91, March, 102-05
　　　　　　　　HALI Publications Ltd 1997

Hollands, H.　　*Drawing A Blank:*
　　　　　　　　Picturing Nothing On The Page
　　　　　　　　Performance Research,
　　　　　　　　Vol.9 No.2 24-33
　　　　　　　　Routledge 2004

Holmes, N. & Hallam, C.
　　　　　　　　The Philosophy of Nothing & Everything
　　　　　　　　APL Quote Quod,
　　　　　　　　Vol.25, No.4, 75-82
　　　　　　　　Association for Computer Machinery 1995

Hoogland, R.　　*"Nothing But A Pack of Cards":*
　　　　　　　　Semi-Fictitious Persons & Floppy Jellyfish
　　　　　　　　In Elizabeth Bowen
　　　　　　　　Women: A Cultural View,
　　　　　　　　Vol.22, No.1, 1-14
　　　　　　　　Taylor & Francis 2011

Hopkins, S. *Sex Object-Ness:*
The Seduction of Being Nothing
Social Alternatives, Vol.16, No.1, 17-19
Central Queensland University Press 1997

Hopp, C. *Nothing Ventured – Nothing Gained?*
Empirical Evidence on Venture Capital
Financing in Switzerland
Revue Suisse d'Economie et de Statistique,
Vol.143, No.3, 239-60
Helbing & Lichtenhaln 2007

Hosken, D.J. *Clitoral Variation Says Nothing About*
Female Orgasm
Evolution & Development,
Vol.10, No.4, 393-395
Blackwell Publishing Ltd 2008

Howarth, P. Mathew Hart.
Nations of Nothing But Poetry:
Modernity, Transnationalism,
& Synthetic Vernacular Writing
Comparative Literature Studies,
Vol.49, No.4, 643-645
Penn State Press US 2012

Hutchings, M.J. *Much Ado About Nothing So Far?*
Journal of Evolutionary Biology,
Vol.17, No.6, 1184-1186
Birkhauser Verlag 2004

Hutchings, P. *Review of Kirk Varnedoe's, **Pictures of***
Nothing: Abstract Art Since Pollock
Sophia, Vol.46, No. 3, 311-312
Springer Science & Business Media 2007

Ilundain-Agurruza, J,

 Nothing New Under The Sun: Holism &
The Pursuit of Excellence
Sport, Ethics & Philosophy,
Vol.8, 3, 230-57
Taylor & Francis UK 2014

Imafidon, E. *Fundamental Questions About Nothing*
Synthesis Philosophica, Vol. 26 Pt 2, 309-22
Croatian Philosophical Society 2011

Inglis, I. *'Nothing You Can See That Isn't Shown':*
The Album Covers of The Beatles
Popular Music,
Vol. 20 Part 1 83-98
2001

Inwood, M. *Does The Nothing Noth?*
Royal Institute of Philosophy Supplement
Issue 44, 271-290
Cambridge University Press 1999

Irimia, M. & Douka-Kabitoglou, E.
Much Ado About Nothing?
Logomachina: Forms of Opposition in
English Language Literature
April, 211-222
Hellenic Association For The Study of
English, Salonika Greece 1993

Iyer, L. *Simon Critchley, Very Little, Almost*
Nothing, Death, Philosophy, Literature
The Journal of The British Society For
Phenomenology,
Vol. 30, No. 3, 336-337,
Haigh & Hochland Ltd 1999

Jablonowski, J.
A New Lease of Life: Change Is Nothing
New In The Machine-Tool Business As
TheLatest Instalment Proves
Machinery, Vol.160, Part 4057, 59
Findlay Publications Ltd 2002

Jackson, J.D., Singh, N. & Thornton, T.
Include Nothing: Reduce Investment
Casting Inclusion Defects
Modern Casting, Vol.94, Part 4, 35-38
American Foundrymen's Soc Inc 2004

213

Jackson, S.E. *Money For Nothing*
 The Journal of Business Strategy: The
 Magazine For The Corporate Strategist,
 Vol.32, No.2, 50-52
 Emerald Group Publishing Ltd 2011

Jacquette, D. *Janaway, C. (Ed.)*
 Willing & Nothingness
 Philosophical Books,Vol. 41, No. 3, 184-185
 Blackwell Publishing 2000

Jacquette, D., Malinowski, J. & Pietruszczak, A.
 Crossroads of Logic and Ontology:
 A Modal-Combinatorial Analysis
 Of Why There is Something
 Rather Than Nothing
 Poznan Studies in The Philosophy of
 Sciences & The Humanities,
 Vol. 91, 17-46
 PS 2006

Jalali, N. Et al *The Tooth, The Whole Tooth & Nothing But*
 The Tooth:
 Can Dental Pain Ever Be The Sole
 Presenting Symptom Of A Myocardial
 Infarction? A Systematic Review.
 The Journal of Emergency Medicine,
 Vol.46, No.6, 865-872
 Elsevier Science B.V. Amsterdam 2014

James, I. *Naming The Nothing:*
 Nancy & Blanchot On Community
 Culture, Theory & Critique,
 Vol.51, 2, 171-87
 Routledge 2010

Janzen, C. *"Nothing Short of A Horror Show":*
 Triggering Abjection of Street Workers
 In Western Canadian Newspapers
 Hypatia: A Journal of Feminist Philosophy,
 Vol. 28, No. 1, 142-162
 Wiley-Blackwell 2011

Janzen, G. *Physicalists Have Nothing To Fear From Ghosts*
International Journal of Philosophical Studies,
Vol.20 No.1, 91-104
Taylor & Francis 2012

Jeffreys, S. Et al
Nothing Mat (t)ers: A Feminist Critique of Postmodernism by Somer Brodribb
Women's Studies International Forum,
Vol.17, No.2/3, 315
Pergamon Press 1994

Jin-Whoo, H. & Meyyappan, M.
The Device Made of Nothing
Institute of Electrical & Electronics Spectrum, Vol.51, NO.7, 30-35
IEEE 2014

Joels, M. & De Kloet, E.R.
Nothing Is Written In Stone
Biological Psychiatry,
Vol.72, No.6, 432-3
Elsevier Science B.V. Amsterdam 2012

Jones, A. *Nothing New Under The Sun: Mary Adams*
People & Science, June, 24
British Science Association 2013

Jones, D. **Stories For Nothing:**
Samuel Beckett's Narrative Poetics
French Studies,
Vol.58, No.2, 288-289
Oxford University Press 2004

Jones, R. *Worried About Woolf: Have Nothing To Fear*
Counsel, Bar Council Journal,
April 10-11
Butterworths 1999

Jones, W.P. & Cowie, J.
 "Nothing Special To Offer The Negro":
 Revisiting The 'Debsian View' of The
 Negro Question
 International Labor & Working-Class
 History,
 No.74, 212-24
 Cambridge University Press 2008

Jorink, E.
 'Outside God There Is Nothing':
 Swammerdam, Spinoza and The Janus
 Face of The Early Dutch Enlightenment
 Brill's Studies in Intellectual History,
 Vol. 120, 81-108
 E.J. Brill 2003

July, M.
 FICTION: "Something That Needs Nothing"
 The New Yorker, 18th Sep., 66-77
 New Yorker Magazine Inc. 2006

Kalender, U.
 Nothing Beyond The Able Mother?
 A Queer-Crip Perspective on Notions of
 The Reproductive Subject in German
 Feminist Bioethics
 International Journal of Feminist
 Approaches To Bioethics,
 Vol.3, No.2, 150-169
 Indiana University Press 2010

Kappler, R. & Energy, H.
 Much Ado About Nothing
 Refocus: Renewable Energy Focus
 Vol.8, No.4, 20-21
 Elsevier Science B.V. Amsterdam 2007

Karimi, M.M. *A. Grûnbaum*
 On The Steady-State Theory
 & Creatio Continua Of Matter
 Out Of Nothing
 Zygon,
 Vol.46, No.4, 857-871
 Blackwell Publishing 2011

Karlsson, T. *Moving With The Markets: Chief Executive*
Of Crown Cork & Seal Europe Says That
The Changes That Have Happened At The
Company In The Last Three Years Are
Nothing To What Will Happen In The Future
The Canmaker, Vol.12, August, 17-20
Sayers Publishing Group Ltd 1999

Kartiganer, D.M., Urgo, J.R. & Abadie, A.T.
"Getting Good At Doing Nothing":
Faulkner,Hemmingway &
The Fiction Of Gesture
Faulkner & Yuknapatawpha Conference;
Faulkner & His Contemporaries,
O, 54-73 Jackson MS 2002
University Press of Mississippi US 2004

Kaser, D. *Nothing But Ephemera*
Information Today: The Newspaper For
Users & Producers of Electronic
Information Services, Vol.28, Issue 8, 3-5
Learning Information Inc 2011

Kaufer, S. *The Nothing & The Ontological Difference*
In Heidegger's, ***What Is Metaphysics?***
Inquiry: An Interdisciplinary Journal of
Philosophy & The Social Sciences,
Vol. 48, No. 6, 482-506
Scandinavian University Press 2005

Keats, J. *Nothing But A Hack*
Discover,
Vol.35, No.7, 54
Kalmbach Publishing 2014

Keever, C.C. & Hart, M.W.
Something For Nothing? Reconstructing
Ancestral Character States in Asterinid
Sea Star Development
Evolution & Development,
Vol.10, No.11, 62-73
Blackwell Publishing Ltd 2008

Kelly, P. ***Nothing Less Than Literal:***
 Architecture After Minimalism
 The Art Book: International Publishing
 Review, Vol. 12, No. 4, 60-61
 Blackwell Publishing 2005

Kelly-Bootle, S. *Nothing Like Show Business*
 UNIX Review, Vol.15, No.8, 87-88
 UR 1997

Kendi, A. Et al *"Nothing Doing. Still An Idea Behind It".*
 The Restoration of Zion
 International J. Joyce Symposium –
 Joyce in Trieste:
 An Album of Risky Readings,
 O, 150-158, 2002

Kerig, P. Et al *Nothing Really Matters: Emotional*
 Numbing as a Link Between Trauma
 Exposure and Callousness in
 Delinquent Youth
 Journal of Traumatic Stress,
 Vol.25, No.3, 272-279
 John Wiley & Sons, Ltd 2012

Kessler, R.J. *Consciousness:*
 "Nothing Happens Unless First A Dream"
 Contemporary Psychoanalysis,
 Vol.49, No.2, 176-188
 W.A. White Institute 2013

Kirsch, A. *Books:**The Nothing That Is** – The Least*
 Known Masterpiece of European Literature
 The New Republic,
 Vol.244, No4953, 412
 New Republic 2013

Klein, R. *How To Get Paid For Doing Nothing*
 Building,
 Vol.273, No. 8513, 55
 The Builder's Group – Building Services
 Publications 2008

Klimov, G.P. & Marshall, G.R.
Measure of Similarity of Amino Acids or How To Obtain The Genetic Code From "Nothing"
Applications: An International Journal,
Vol.31, No.8, 13-22
Pergamon Press 1996

Klooger, J. *The Guise of Nothing*
Critical Horizons: A Journal of Philosophy & Social Theory,
Vol. 14, Supp/1
Maney Publishing 2013

Knight, L. *In Itself Nothing*
Southern Humanities Review,
Vol.31 No.4 319
Auburn University, Alabama 1997

Kobbe, U. *Being & Nothingness of The Prisoner of The Dreams:*
Outlines of A Philosophy & Cartography (Of The Subject) Of The Dream
Revue Francaise De Psychiatrie Et De Psychologue Medicale,
No. 60, 25-30
RFPPM 2002

Kobrak, M.N. *A Mathematical Proof That Nothing Is True*
The Journal of Irreproducible Results,
Vol.5, No.1, 22
SBIR2006

Koskinen, M. Et al
"Everything Represented, Nothing Is".
Some Relations Between Ingmar Bergman's Films & Theatre Productions
Interart Studies:
New Perspectives, Itinerant Poetics,
99-108, Lund Sweden, May 1995
Rodopi, Atlanta GA/Amsterdam 1997

Kosoi, N. *Art For Nothing: Nothingness in The Myths*
 Of Pliny Regarding Painting
 Angelaki: Journal of The Theoretical
 Humanities,
 Vol. 17, No3, 97-103
 Taylor & Francis 2012

 Nothingness Made Visible:
 The Case of Rothko's Paintings
 Art Journal, Vol. 64, No. 2, 20-31
 College Art Association, New York 2005

Kotchoubey, B *Signifying Nothing?*
 Myth & Science of Cruelty
 The Behavioural & Brain Sciences,
 Vol.29, No.3, 232
 CUP 2006

Kovacs, A.B. *Sartre, The Philosophy of Nothingness*
 & The Modern Melodrama
 The Journal of Aesthetics & Art Criticism,
 Vol. 64, No. 1, 134-145
 Blackwell Publishing Ltd 2006

Kraus, C. *Of 'Epistemic Covetousness' In Knowledge*
 Economies: The Not-Nothings of
 Social Constructionism
 Social Epistemology: A Journal of
 Knowledge, Culture & Policy,
 Vol. 19, No. 4, 339-356
 Taylor & Francis 2005

Krauss, N. *Nothing Rhymes With White:*
 RichardAvedon's Portraits
 Modern Painters,
 Vol. 15, Part 4, 40-43
 Fine Art Journals Ltd, 2000

Krysan, D.J. *Nothing But Tears*
 Emerging Infectious Diseases,
 Vol.15, No.5, 854
 NCFID 2009

Kubiak, A.D. *Godot: The Non-Negative Nothingness*
Romance Notes, Vol. 48, No. 3, 395-405
Dept. of Romance Languages 2008

Kucera, C.M. *Hayfever Is Nothing To Sneeze At*
Asthma Magazine, Vol.9, No.2, 10-12
Elsevier Science B.V. Amsterdam 2004

Labanyi, P. *When Nothing Is Ever Good Enough:*
Our Development Need For Perfection
&Idealization
Eisteach: A Quarterly Journal of Counselling
& Therapy, Vol.10, No.3, 7-11
Irish Assn For Counselling & Therapy 2010

Lagapa, J. *Something From Nothing:*
The Disontological Poetics of Leslie Scalpino
Contemporary Literature,
Vol. 47, No. 1, 30-61
University of Wisconsin Press 2006

Lambert, D. *Much Ado About Nothing:*
The Highly Charged Subject of Hybrids
Aquarist & Pondkeeper,
Vol.60, No5, 105
Dog World Publications 1995

Landau, I. *Sartre's Absolute Freedom in **Being &***
***Nothingness**:*
The Problems Persist
Philosophy Today,
Vol. 56, No. 4, 463-473
De Paul University, Chicago 2012

Landau, M.J. Et al
Windows Into Nothingness:
Terror Management ,
Meaninglessness
& Negative Reactions To Modern Art
Journal of Personality & Social Psychology,
Vol. 90, No. 6, 879-892
APA 2006

Landis, R.S. & Regelberg, S.G.
Our Scholarly Practices Are Derailing Our
Progress:
The Importance of Nothing
In The Organisational Sciences
Industrial & Organisational Psychology:
Perspectives On Science & Practice,
Vol.6, No.3, 299-302
Blackwell Publishing Ltd 2013

Lane, C.
Lewis Carroll & Psychoanalysis:
Why Nothing Adds Up In Wonderland
International Journal of Psychoanalysis,
Vol.92, No.4, 1029-1045
Blackwell Publishing Ltd 2011

Laqueur, T.W.
Smoking & Nothingness:
Tobacco In History, *by Jordan Goodman*
The New Republic, Issue 4209, 39
NR 1995

Larrabee, M.J., Weine, S. & Woolcott, P.
"The Wordless Nothing":
Narratives of Trauma & Extremity
Human Studies: A Journal for Philosophy
& The Human Sciences
Vol. 26, No.3, 353-382
Kluwer Academic Publishers 2003

Laycock, S.W.
The Dialectics of Nothingness:
A Re-examination of Shen-Hsiu
& Hui-Neng
Journal of Chinese Philosophy,
Vol. 24, No. 1, 19-42
Dialogue Publishing Co 1997

Lease, B.
Opening Borders, Closing Nations:
How 'Generation Nothing' Stages
PolishMigration
Contemporary Theatre Review,
Vol. 24 No. 1 6-20
Taylor & Francis UK 2014

Le Corre, M. & Carey, S.
 One, Two, Three, Four, Nothing More: An
 Investigation of The Conceptual Source of
 The Verbal Counting Principles
 Cognition, International Journal of
 Cognitive Science, Vol.105, No.2, 395-438
 Elsevier Science B.V. Amsterdam 2007

Lee, C.J.
 Criticism & The Theory of Nothingness
 Philosophy & Literature,Vol, 27, 1. 211-22
 The John Hopkins UP, Baltimore 2003

Lee, P.C.
 There Is Nothing More Than Dressing Or
 Eating?
 Li-Zhi ? & The Child-like Heart-Mind
 (Tongxin ?
 Dao: A Journal of Comparative Philosophy,
 Vol. 11, No. 1, 63-81
 Springer Science & Business Media 2012

Lehmann, C.
 Much Ado About Nothing?
 Shakespeare, Branagh
 & The "National-Popular"
 In The Age of Multinational Capital
 Textual Practice,
 Vol.12, No.1, 1-22
 Routledgte Journals 1998

Leitch, T.M.
 Know-Nothing Entertainment: What To
 Say To Your Friends On The Right, And
 Why It Won't Make Any Good
 Literature Film Quarterly,
 Vol. 24 No.1 7-17
 Salisbury State College 1997

Levin, A.M., Dato-On, M.C. & Rhee, K.
 Money For Nothing & Hits For Free:
 The Ethics of Downloading Music
 From Peer-To-Peer Web Sites
 Journal of Marketing Theory & Practice,
 Vol.12, No.1, 48-60
 AMTP 2004

Levine, E.S. & Anshel, D.J.
Nothing Works! A Case Study Using Cognitive Behavioural Interventions To Engage Parents, Educators, & Children in The Management of Attention-Deficit /Hyperactivity Disorder
Psychology in Schools, Vol.48, 3, 297-306
John Wiley & Sons, Ltd 2011

Levine, S.S.
Nothing But The Truth: Self-Disclosure, Self-Revelation & The Persona of The Analyst
Journal of The American Psychoanalytic Association, Vol.56, Part 1, 81-104
International Universities Press Inc 2007

Lewis, E.E.
Much Ado About Nothing: Response Matrices For Void Regions
Annals of Nuclear Energy, 31,17, 2025-37
Elsevier Science B.V. Amsterdam 2004

Liddie, A.
*Zilch: **The Book of Nothing** by J.D. Barrow*
Notes & Records of The Royal Society of London, Vol.56, Part 1, 101
University Press 2002

Likin, M.
"Nothing Fails Like Success": TheMarxism of Raymond Aron
French Politics, Culture & Society, Vol. 26, No.3, 43-60
Berghahn Books 2008

Lippert-Rasmussen, K.
Nothing Personal: Statistical Discrimination
The Journal of Political Philosophy, Vol. 15, No. 4, 385-403
Blackwell 2007

Llang, B.A.
Taking Nothing For Granted
Journal of Biolaw & Business, Vol. 12, No. 4, 15
Applied Biogenuity 2009

Loevlie, E. *Poetic Language & The Expression of*
 Nothing: Towards A Kenotic Weakening
 Of Referential Language
 Angelaki: Journal of The Theoretical
 Humanities,
 Vol. 17, No. 3, 85-96
 Taylor & Francis 2012

Loewy, I. *"Nothing More To Be Done": Palliative*
 Care Versus Experimental Therapy in
 Advanced Cancer
 Science in Context, Vol.8, No.2, 209
 Cambridge University Press 1995

Lombardi, R. *The Body Emerging From The "Neverland"*
 Of Nothingness
 The Psychoanalytic Quarterly,
 Vol. 79, No. 4, 879-810
 PQ 2010

Lu, H. Et al *Pipelined Band Join in Shared-Nothing*
 Systems
 Journal of Data Semantics,No. 1023, 239-53
 Springer-Verlag KG 1995

Lucas, C. *A Graphic Memoir: Probably Nothing*
 The Lancet Oncology,
 Vol.16, No.1, 21
 Elsevier Science B.V. Amsterdam 2015

Lui, C. *Being & Nothingness: Chinese Artist*
 Xu Bing's Calligraphic Works Blur The
 Divides of Language & Meaning , Past &
 Present, Truth & Lies
 Print, Vol. 58, Part 2, 90-95
 Bruil & Van De Staaij 2004

Lukas, P. *Designer 'Zines: When Typography Is Just*
 Another Word For Nothing Left To Do
 AIGA Journal of Graphic Design,
 Vol. 14 No. 3, 34-35
 American Institute of Graphic Arts, 19 96

Lynch, M.T., Cobb, C.J. & Hester, M.T.
 "Conquered Nations Mean Nothing In Love". Political Dissent in Propertius's, Elegy11.7 and Donne's, "Love's Warre"
 Renaissance Papers: SE Renaissance Conference,
 O, 77-90, Chapel Hill, NC 2006
 Boydell & Brewer, Camden House 2006

Macbride, F.
 Could Nothing Matter?
 Analysis, Vol.62, Part 2, 125-134
 Blackwell Publishers, 2002

Macmillan, I.
 I'm Saying Nothing, Martin Creed: A Countdown
 Modern Painters, Vol. 13 Part 1, 42-45
 Fine Art Journals Ltd, 2000

Madigan, P.
 Deconstructing Theodicy: Why Job Has Nothing To Say To The PuzzleOf Suffering, By David B. Burrell
 Heythrop Journal,
 Vol. 50, No. 5, 902
 Blackwell Publishing Ltd 2009

Magana, G. & Levine, S.J.
 Nothingness In The Rough
 Common Knowledge,
 Vol. 19, Issue 1, 171-179
 Duke University Press 2013

Manheimer, R.
 The Paradox of Beneficial Retirement: A Journey Into The Vortex of Nothingness
 Journal of Aging, Humanities & The Arts,
 Vol. 2, No. 2, 84-98
 Taylor & Francis 2008

Martinez, F.
 There's Nothing Mystical About Applying For a Design Patent
 Interiors – New York,
 Vol. 159 Part 8 37-38
 BPI Billboard Publications Inc 2000

Masters, G. *Why Failure Is Nothing We Need Fear*
Professional Educator, Vol. 5, No. 3, 12-15
Acer Press 2006

Mazurek, S. *The Individual & Nothingness*
*(**Stavrogin**: A Russian Interpretation)*
Studies In East European Thought,
Vol. 62, No. 1, 41-54
Springer 2010

McArthur, M. *"The Index of Nothing Affirmeth": The*
Semiotic Formation of A Literary Mandate
*In James Joyce's, "**The Sisters**"*
James Joyce Quarterly, Vol.45, No.2, 245-62
University of Tulsa 2008

McCloskey, D.
 Signifying Nothing:
 Reply to Hoover & Siegler
 Journal of Economic Methodology,
 Vol.15, No.1, 39-55
 Taylor & Francis 2008

McCormick, P., Haapala, A. & Kuisma, O.
 "What Came About Brought To Nothing":
 Negative Aesthetic Value
 Acta Philosophica Fennica, Vol. 72, 33-44
 Philosophical Society of Finland 2003

McCoy, B.H. *Nothing Lasts Forever*
Urban Land, Vol.66, No.2, 48-51
The Urban Land Institute 2007

McDaniel, K. *Being & Almost Nothingness*
Noûs, Vol. 44, No. 4, 628-649
Blackwell Publishing 2010

McGhee, M. *Is Nothing Sacred?*
A Secular View of Incarnation
Philosophical Investigations,
Vol.34, No2, 169-188
Blackwell Publishing Ltd 2011

McGoveran, D. *Nothing From Nothing: The Conclusion*
Database Programming & Design,
Vol.7, No.3, 54
DPD 1994

McLoughlin, P.J. *'It's a United Ireland or Nothing'? John*
Hume and The Idea of Irish Unity 1964-72
Irish Political Studies, Vol.21, No2, 157-80
IPS 2006

McQueen, R. *The Book & Nothing But The Book*
International Journal of The Legal
Profession, Vol.11, No.1/2, 111-116
Carfax Publishing Company 2004

Maher, A. *"Swastika Arms of Passage Leading To*
Nothing":
Late Modernism & The "New" Britain
ELH: A Journal of English Literary History,
Vol.80, No.1, 251-286
The John Hopkins University Press 2013

Mainville, S. & Valerius, L.
Nothing But Net:
Therapeutic Recreation&The Web
Parks & Recreation,
Vol.34, No.5, 86-93
National Recreation & Parks Association
1999

Mannon, S.E. *Pampered Sons, (Wo)manly Men, or*
Do-Nothing Machos? Costa Rican Men
Coming of Age Under Noeliberalism
Bulletin of Latin American Research,
Vol.29, No.4, 477-491
Blackwell Publishing Ltd 2010

Mantle, G. & Moore, S.
On Probation: Pickled & Nothing To Say
The Howard Journal of Criminal Justice,
Vol.43, No.3, 299-316
Blackwell Publishing Ltd 2004

Mathews, R. *Nothing Like A Vacuum*
New Scientist, Issue 1966, 30
IPC Magazines 1995

May, R. *When Nothing Tells You Something*
Trends in Cell Biology,
Vol.10, No.3, 91
TCB 2000

Mellers, W. *The Silence of Nothingness &American*
Abstraction: On John Cage
Modern Painters,
Vol. 11, No. 1, 88-92
Fine Art Journals Ltd 1998

Menzies, J. *Luck of The Irish – Their Success Has*
Nothing To Do With Fortune. It's All
Down To Hard Work & Practice
The Field – The Country Newspaper
Vol. 319, No.7292, 58-62
IPC Magazines Ltd 2012

Merritt, D.J. & Brannon, E.M.
Nothing To It: Precursors To
Zero ConceptIn Preschoolers
Behavioural Processes,
Vol.93, 91-97
Elsevier Science B.V. Amsterdam 2013

Metcalf, D. *Nothing New Under The Sun:*
ThePrescience of W.S. Saunders'
1906 Fabian Tract
British Journal of Industrial Relations,
Vol.47, No.2, 289-306
Blackwell Publishing Ltd 2009

Metz, W. *"Signifying Nothing?": Martin Ritt's,*
***The Sound & The Fury** (1959)*
As Deconstructive Adaptation
Literature Film Quarterly,
Vol.27, No.1 21-31
Salisbury State College, 1999

Metzenrath, S. *Sexual Servitude:*
 Labour Migration For The Purpose Of
 Working In The Sex Industry Is No More
 Than An Element Of The International
 Movement of Labour
 National Aids Bulletin,
 Vol.12, No.4, 24-25
 AFAO 1999

Miah, A. *Virtually Nothing:*
 Re-evaluating The
 Significance of Cyberspace
 Leisure Studies,
 Vol. 19 Part 3 211-25
 E & FN SPON 2000

Miller, M.F. *'Twernt Nothing Serious*
 The Journal of The Kentucky Medical
 Association,
 Vol.95, No.7, 291-294
 KMA 1997

Mizogouchi, M. *As I Find Nothing Else To Do*
 Taikabatsu,
 Vol.50, No.8, 409
 Technical Association of Reflectories,
 Japan 1998

Mohaghegh, J.B. & Golesthaneh
 Haunted Sound:
 Nothingness, Movement
 & The Minimalist Imagination
 Environment & Planning. D.
 Society & Space,
 Vol. 29, No. 3, 485-498
 Pion Ltd 2011

Molyneux, B. *Why Experience Told Me Nothing About*
 Transparency
 Noûs,
 Vol.43, No.1, 116-136
 Blackwell Publishers 2009

Monk, L. *Apropos of Nothing:*
 Chance & Narrative In
 *Foster's, **A Passage To India***
 Studies In The Novel,
 Vol. 26, No. 4, 392
 University of North Texas 1994

Montag, W. *The Late Althusser:*
 Materialism of The Encounter
 Or Philosophy of Nothing?
 Culture, Theory & Critique,
 Vol.51, No.2, 157-70
 Routledge, London 2010

Moore, M. *Andrew Stein,*
 Longing For Nothingness:
 Resistance, Denial & The Place of Death
 In The Nursing Home
 American Journal of Psychoanalysis,
 Vol. 72, No. 1, 86-89
 Palgrave-Macmillan 2012

Morse, J.M. *"Nothing Is Ever Perfect":*
 The Problem Of Submitting Articles
 To An International Journal
 Qualitative Health Research,
 Vol.19, No.3, 295-296
 Sage Publications Inc 2009

Moten, F. & Carter, J.K.
 Blackness & Nothingness
 (Mysticism In The Flesh)
 The South Atlantic Quarterly,
 Vol. 112, No. 4, 737-780
 Duke University Press, Durham NC 2013

Mulhall, S. & O'Hear, A.
 Why Is There Something Called Philosophy
 Rather Than Nothing?
 Royal Institute of Philosophy Supplement,
 Issue 65, 257-274
 Cambridge University Press 2009

Mullich, J. *It's Nothing Automatic*
 Open Systems Computing,
 Vol.12, No.2, 46
 McGraw-Hill Companies 1995

Munby, J. *The Work of Art in The Age of Hip Hop*
 Reproduction: Ice-T & The Cultural
 Capital of Keeping It Real Again in
 Kings of Vice (2011) & Something From
 ***Nothing - The Art of Rap** (2012)*
 Journal For Cultural Research,
 Vol.17, No.4, 382-397
 Taylor & Francis UK 2013

Munro, M. & Gallagher, M.
 Something & Nothing: Place &
 Displacement in Aime Cesaire
 & Rene Depestre
 Cross/Readings in The Post/Colonial
 Literatures, Sept', 243-146, Dublin
 Rodolpi, Amsterdam 2003

Myhill, N. *Spectatorship in **Much Ado About Nothing***
 Studies in English Literature 1500-1900,
 Vol.39, No.2, 291-312
 Rice University, Houston 1999

Nancy, J.L. *Nothing But The World:*
 *An Interview with**Vacarme***
 Rethinking Marxism, Vol.19, No.4, 521-535
 Taylor & Francis UK 2007

Nanda, J. *Mindfulness, Nothing Special, Yet Special*
 Existential Analysis,
 Vol. 21, No. 1, 41-50
 The Society for Existential Analysis 2010

Nayak, S. *"Nothing In That Other Kingdom":*
 *Fashioning A Return To Africa In **Omeros***
 Ariel: A Review of International Literature
 Vol.44, No.2/3, 1-28
 The University of Calgary Press 2013

Nederhood, R. *All or Nothing:*
The Supreme Court Answers
The Question, "What's In A Name?"
The Journal of Criminal Law & Criminology
/North-Western School of Law,
Vol.96, No.3, 809-38
North Western University 2005

Neel, A. *"A Something-Nothing Out Of Its Very*
Contrary";
The Photography of Coleridge
Victorian Studies,
Vol.49, No.2, 208-217
Indiana University Press 2006

Nelson, E.S. *Demystifying Experience:*
Nothingness & Sacredness
In Heidegger & Chan Buddhism
Angelika: Journal of The Theoretical
Humanities,
Vol. 17, No. 3, 65-74
Taylor & Francis 2012

Newland, P. *To The West There Is Nothing...*
Except America:
The Spacial Politics of Local Hero
Visual Culture in Britain,
Vol. 12 No.2 171-84
Taylor & Francis UK 2011

Ni, L. *Zero & Metaphysics:*
Thoughts About Being & Nothingness
From Mathematics, Buddhism, Daoism
To Phenomenology
Frontiers of Philosophy in China,
Vol. 2, No. 4, 547-556
Springer Science & Business Media 2007

Nilsen, A. *'History Does Nothing': Notes Towards a*
Marxist Theory of Social Movements
Sosiologisk Arbok, 1/2, 1-30
SA 2007

Nishri, A. & Saccavini, M.

Spinal Cord Injury: There Is Nothing
Permanent Except Change
(Heraclitus, 540-480BC)
Brain Research Bulletin, Vol.78, No.1, 2-3
Elsevier Science B.V. Amsterdam 2009

Norell, M.

There's Nothing Like A Soak In A Long,
Hot Bath
British Journal of Cardiology, Vol.18, 2, 70
MediNews Ltd 2011

Novak, B.

Anselm on Nothing
International Philosophical Quarterly
Vol. 48, No.3, Issue 91, 305-320
FIPE 2008

Nugent, D.

How The Gardai Got Back In The Saddle
& Police Horses Returned To Dublin
Streets: There's Nothing Supernatural
*About **The Equus Files***
Irish Veterinary Jrnal, Vol.51, No10, 514-16
R & W Publications (Newmarket\) Ltd 1998

Obladen, M.

Much Ado About Nothing: Two Millennia
Of Controversy on Tongue-Tie
Neonatology: Foetal & Neonatal Research,
Vol.97, No.2, 83-89
S. Karger AG 2010

O'Brian, T.

Faith & Authenticity:
Kierkegaard & Heidegger On Existing In
'Closet Closeness' To The Nothing
Faith & Philosophy: Journal of The Society
Of Christian Philosophers,
Vol. 20, No. 1, 72-84
The University of Notre Dame 2003

O'Neill, B.

Ireland's Peace of Nothing
Living Marxism,
Issue 10, No. 4, 521-35
Taylor & Francis 2007

Orenstein, A. *How To Get Something From Nothing*
 Proceedings of The Aristotelian Society
 For The Systematic Study of Philosophy
 Vol. 95, 93
 The Aristotelian Society 1995

Oshio, A. *An All-or-Nothing Thinking Turns*
 Into Darkness:
 Relations Between Dichotomous
 Thinking Personality Disorders
 Japanese Psychological Research,
 Vol.54, No.4, 424-429
 Blackwell Publishing Ltd 2012

Pack, R. *Place & Nothingness*
 In The Poetry of Wallace Stevens
 The Wallace Stevens Journal,
 Vol. 27, Part 1, 97-115
 The Wallace Stevens Society, Inc 2003

Papoli-Yazdi, L. & Naeimi, M.
 Portraits In The Background of Nothingness?
 Sheikh Jabber Burnt House, An Object
 Of Persian Gulf War
 Archaeologies,
 Vol. 8, No. 2, 145-168
 Springer Science & Business Media 2012

Paranjape, A., Lam, T.Y. & Sheth, R.K.
 A Hierarchy of Voids:
 More Ado About Nothing
 Monthly Notices of The Royal Astronomical
 Society,
 Vol.420, No.2, 1648-1655
 Blackwell Publishing 2012

Paterson, C. *Nothing Is More Or Less Alive:*
 A Conversation
 With Edouardo Kac
 Sculpture,
 Vol. 30 No.3 48-55
 The International Sculpture Centre, 2011

Pearce, K.L. *Tyron Goldschmidt, Ed., The Puzzle of*
 Existence: Why Is There Something Rather
 Than Nothing?
 Faith & Philosophy: Journal of The Society
 Of Christian Philosophers,
 Vol. 31, No. 3, 341-344
 The University of Notre Dame 2014

Pelaez, S. *Ungrounding The Nation:*
 A Reading of Juan Jose Saer's,
 Nobody, Nothing Ever (Nade Nada nunca)
 The New Centennial Review,
 Vol.14, No1, 1-24
 Michigan State University Press 2014

Perl, J. *There Is Nothing Surprising About*
 Los Angeles' Hankering For Jeff Koons.
 But What About Its Hankering For
 Bernini?
 A Critical Tour
 Through L.A. As An Art Town
 The New Republic,
 Vol.240, No4860, 29-34
 New Republic 2000

Pietz, A. & Rivieccio, U.
 Nothing But The Truth
 Journal of Philosophical Logic,
 Vol. 42, No. 1, 125-135
 Springer Science & Business Media 2013

Pigliucci, M. *On Naturalism:*
 It Has Nothing To DoWith Nudity
 Philosophy Now, Issue 96, 47
 PN 2013

Pilling, J. *Paul B. Kelley,*
 Stories For Nothing:
 Samuel Beckett's Narrative Poetics
 The Modern Language Review,
 Vol. 99, Part 2, 748-779
 Modern Humanities Research Assn 2004

Pini, R.C. *When It's Perfection or Nothing, Quality*
 Leaders Turn to Photonics
 Photonics Spectra, Vol.33, No.5, 102-115
 Laurin Publishing Company Inc 1999

Pogliani, L., Randic, M. & Trinajstic, N.
 Much Ado About Nothing –
 An Introductive Inquiry About Zero
 International Journal of Mathematical
 Education in Science & Technology,
 Vol.29, No.5, 729-44
 Taylor & Francis 1998

Pomerantz, B. *Speech! Speech!*
 You Haven't Heard Nothing Yet!
 Internet Reference Services Quarterly: A
 Journal of Innovative Information Practice,
 Technologies & Resources,
 Vol.3, No.4, 95-99
 IRSQ 1998

Pomper, S. *Eyes on The Pries:*
 Why Surveillance Technology Should Worry
 Those With Nothing To Hide
 The Washington Monthly,
 Vol.36, Part 1/2 48-49
 Washington Monthly Company 2007

Pontious, J.M. *Nothing Happens In Isolation*
 Journal of The Oklahoma State Medical
 Association,
 Vol.102, No.2, 46
 OSMA 2009

Poole, R. *Simon Critchley,*
 Very Little... Almost Nothing,
 Death, Philosophy, Literature
 Parallax: A Journal of Metadiscursive Theory
 & Cultural Practices,
 Vol. 5, Part 1, 124-126
 Taylor & Francis 1999

Priest, G. *Jody Azzouni:*
 Talking About Nothing
 Oxford University Press, New York 2010
 Philosophica Mathematica,
 Vol.19, No.3, 359-363
 University of Toronto Press 2011

Prince, A. *Much Ado About Nothing*
 American Journal of Bioethics,
 Vol. 10, No. 11, 22
 Taylor & Francis 2010

Principe, G.F.& Smith, E.
 The Tooth, The Whole Tooth & Nothing
 But The Tooth:
 How Belief In The Tooth Fairy
 Can Engender False Memories
 Applied Cognitive Psychology,
 Vol.22, No.5, 625-642
 John Wiley & Sons, Ltd 2008

Punjabi, P.P. *Wisdom Is Knowing You Know Nothing*
 Perfusion,
 Vol.27, No.6, 454
 Sage Publications 2012

Purvis, M. *Nothing Endures But Change*
 Metal Finishing, Vol.102, No.9, 2
 Elsevier Science B.V. Amsterdam 2004

Qian, Z. *Late Stevens, Nothingness & The Orient*
 The Wallace Stevens Journal,
 Vol. 25, Part 2, 164-172
 The Wallace Stevens Society, Inc 2001

Quigley, P. *'Expect Nothing/Nothing Is Strange'"':*
 Nature and The Poetics of Cultural
 Collapse & Renewal
 College English Association – Critic,
 Vol.60, No.1, 35-59
 CEA Publications 1997

Raben, N. *Autophagy & Mitochondria in Pompe's Disease: Nothing Is So New As What Has Long Been Forgotten*
American Journal of Medical Genetics.
Part C/Seminars in Medical Genetics,
Vol.160, No.1, 13-21
John Wiley & Sons, Ltd 2012

Rachels, S. & Alter, T.
Nothing Matters in Survival
Journal of Ethics, Vol.9 No. 3-4, 311-330
Springer Science & Business Media 2005

Rappolt, M. *Ori Gersht: Being & Nothingness*
Modern Painters, April, 90-93
Fine Art Journals Ltd, London 2005

Rapt, J.E. *Doing Nothing – Harry Langdon & The Performance of Absence*
Film Quarterly, Vol.59 Part 1, 27-35
University of California Press, 2005

Redding, P. Review of *Nations of Nothing But Poetry: Modernity, Transnationalism, & Synthetic Vernacular Writing* by Mathew Hart
College Literature, Vol.39, No.1, 143-146
West Chester University 2012

Redhead, M. *Nothingness: The Science of Empty Space*, H. Genz
Nature, Issue 6720, 578
Macmillan Magazines Ltd 1999

Reichenbach, B.R.
*Bede Rundle, **Why There Is Somthing Rather Than Nothing**;
Paul Copan & William LandCraig, **Creation Out of Nothing: A Biblical, Philosophical & Scientific Exploration***
Faith & Philosophy, Vol. 23, No. 1, 107-110
The University of Notre Dame 2006

Reiheld, A. *"The Event That Was Nothing":*
 Miscarriage As A Liminal Event
 <u>Journal of Social Philosophy</u>,
 Vol. 46, Issue 1, 9
 John Wiley & Sons, Inc 2015

Reinfurt, D. *Doing Nothing Doing Something*
 <u>Modern Painters</u>, October, 52-57
 Fine Art Journal Ltd 2006

Ricciardi, J. *Patel's, **The Value of Nothing**:*
 Between Marx, Macroeconomics,
 & Common Resistance
 To Contemporary Enclosure
 <u>Journal of Asian & African Studies</u>,
 Vol.46, No.3, 307-13
 E.J. Brill 2011

Rice, H.C. *Witold Lutoslawski & The Craft of*
 Writing Nothing
 <u>Tempo</u>,
 No 253, 21-29
 Cambridge University Press 2010

Richards, M.C. *Form Out Of Nothingness*
 <u>Studio Potter</u>,
 Vol. 26, No. 1, 10-15
 SP Northampton 1997

Richmond, S. *Sartre & Bergson:*
 A Disagreement About Nothingness
 <u>International Journal of Philosophical</u>
 <u>Studies</u>, Vol. 15, No. 1, 77-95
 Taylor & Francis 2007

Richter, D. *Nothing To Be Said:*
 Wittgenstein &Wittgensteinian Ethics
 <u>The Southern Journal of Philosophy</u>,
 Vol. 34, No.2, 243-256
 Memphis State University,
 Tennessee 1996

Rigsby, C.A. *Three Strands of Nothingness in Chinese*
Philosophy & The Kyoto School:
A Summary & Evaluation
Dao: A Journal of Comparative Philosophy,
Vol. 13, No. 4, 469-489
Springer Science & Business Media 2014

Ritson, M. *What Do The Riots Mean For Brands?*
Nothing
Which? September, No.58 2011

Ritzer, G. *The Globalisation of Nothing*
SAIS Review, Vol. 23, Part 2, 189-200
John Hopkins (Foreign Policy) 2003

Robson, M. *Who Knows The Price of Everything But*
The Value of Nothing?
Mathematics Today, Vol.34, No.3, 699-703
American Mathematical Society 1998

Rodriguez-Peyrera, G.
'There Might Be Nothing: The Subtraction
Argument Improved',
Analysis, 57 (3) 159-166
1997

Rosenbaum, L.
The Art of Doing Nothing
The New England Journal of Medicine,
Vol. 365, No.9, 782
Massachusetts Medical Society 2011

Rosh, A.J. *Doing Something By Doing Nothing*
The Journal of Emergency Medicine,
Vol.38, No.1, 93-94
Elsevier Science B.V. Amsterdam 2010

Ross, F.P. & Christiano, A.M.
Nothing But Skin & Bone
Journal of Clinical Investigation,
Vol.116, No.5, 1140-49
ASCI 2006

Ross, N.	*"Nothing Human Is Foreign To Me":*
	On The Role of Difference
	In Hegel's Aesthetics
	Philosophy Today, Vol.53, No.4, 337-40
	De Paul University, Chicago 2009

Roth, P.A. & Jacquette, D.
	Why There Is Nothing Rather Than
	Something: Quine on Behaviourism,
	Meaning & Indeterminacy
	Philosophical Studies, Vol. 91 263-88
	PS 2003

Roulston, C.	*Histories of Nothing:*
	Romance & Femininity
	In Charlotte Lennox's,
	The Female Quixote
	Women's Writing: The Elizabethan To
	Victorian Period, Vol.2, 25
	Triangle Journals Ltd 1995

Rowe, J.	*The Man Who Said Nothing. It's A Noisy*
	World. Many of Us Feel We Have To Shout
	To Be Heard But One Man, John Francis
	Did Something Different. He Stopped
	Talking For 17 Years
	Ecologist, Vo.37, No.4, 28-32
	Ecosystems Ltd 2007

Rowlands, M.	*Jean-Paul Sartre's, **Being & Nothingness***
	Topoi: An International Review of
	Philosophy, Vol. 30, No. 2, 175-180
	Springer 2011

Roy, R.	*Much Ado About Nothing: Details of What*
	Exactly Has Been Happening in The US
	Cement Industry in The Last Year, &
	Gauges of The Effect of The Forthcoming
	Election Campaign on Cement Demand
	International Cement Review, April 20-27
	A Tradeship Publication 1996

Rudie, R. *The Textile Report: If You've Seen Nothing*
 New in Denim... Look Again!
 Bobbin, Vol.39, No.8, 24-33
 Bobbin Media Corporation 1998

Sanders, K.R. *Much Ado About 'Nothing':*
 (Non-Roman Script Word) & (Non-Roman
 Script Word) in Parmenides
 Apeiron: A Journal For Ancient Philosohy &
 Science,
 Vol. 35, Part 2, 87-104
 Academic Printing & Publishing 2002

Sapolsky, R. *A Gene For Nothing: Are Your Genes Really*
 The Masters of Your Fate?
 Discover,
 Vol.18, No.10, 40-49
 Discover – Palm Coast Data 1997

Schermer, M. *Nothing But The Truth? On Truth &*
 Deception in Dementia Care
 Bioethics, Vol.2, No.1, 13-22
 Blackwell Publishing Ltd 2007

Schindler, D. *Taxing Nothing – Tax Arbitrage & The*
 Vanishing Revenue From Capital Income
 Taxation
 Journal of Economics,
 Vol.82, Part 1, 25-48
 Springer-Verlag, Berlin 2004

Schmidt, J. *Who Says There's Nothing We Can Do?*
 RN – Montvale,
 Vol.58, No.10, 30
 RN Magazine 1995

Schneider, J. **The Boy Will Come To Nothing!** *By*
 Leonard Stengold
 Journal of The American Psychoanalytic
 Association, Vol.43, No.3, 895
 International Universities Press Inc 1995

Schwabsky, B. *KIYOMI IWATA. The Artist's Sculptural*
Forms May Appear To Be Containers, Yet
They Contain Nothing Other Than Their
Own Fragility And Beauty
American Craft, Vol. 62 Part 6, 58-61
ACC 2003

Scotford, J. *Capital Accounting:*
Doing Nothing Is NotAn Option
Public Finance & Accounting: Journal of
The Chartered Institute of Public Finance &
Accounting,19-02-93, 12
CIPFA 1993

Seedhouse, D. *Why Bioethicists Have Nothing Useful To*
Say About Health Care Rationing
Journal of Medical Ethics, Vol. 21, 5, 288
British Medical Journal Publishing 1995

Selfert, R. *Employment: Zero-Hours Contracts*
Nothing New Under The Sun
Business Law Review, Vo.34, No.6, 227
Kluwer Law International 2013

Sendbuchler, F. & Wood, S.
 The Art of Doing Nothing
Angelaki: Journal of The Theoretical
Humanities, Vol. 2, No. 1, 169
Taylor & Francis UK 1995

Sewell, E. *"In The Midst of His Laughter & Glee":*
Nonsense & Nothingness in Lewis Carroll
Soundings, Vol. 82, Part 3-4, 541-572
Society For Values in Higher Education1999

Sewell, L. *'In The End, The One Who Has Nothing*
Wins':
Louise Gluck & The Poetics of Anorexia
Lit: Literature, Interpretation, Theory,
Vol. 17, No. 1, 49-76
Taylor & Francis UK 2006

Shaffer, J. *Nothing But Net:*
 What Can Web PortalsDo For You?
 American Printer, March 28-33
 Primedia Inc 2007

Shakespeare, S. & Pattison, G.
 Books About Nothing?
 Kierkegaard's Liberating Rhetoric
 Person & Polis "After Modernism",
 O, 97-111 Lancaster 1995
 Macmillan, Basingstoke 1998

Shier, D. *Why Kant Finds Nothing Ugly*
 The British Journal of Aesthetics,
 Vol. 38, No.4, 412-418
 Oxford University Press 1998

Short, J. *On An Obligatory Nothing:*
 Situating The Political
 In Post-Metaphysical Community
 Angelaki:
 Journal of The Theoretical
 Humanities,
 Vol. 18, No. 3, 139-154
 Taylor & Francis 2013

Shulman, M. Book Review –
 Nothing Good Is Allowed To
 Stand: An Integrative View of The Negative
 Therapeutic Reaction
 Journal of The American Psychoanalytic
 Association, Vol. 62, Issue 1, 149
 Sage Publications 2014

Siegel, G.W. *Nothing Causes Something:*
 Expansion Rates
 Of Universes
 & Bell Sizes
 The Journal of Irreproducible Results;
 Vol.50, No.1, 23-24
 Soc. For Basic Irreproducible Results 2006

Simpson, J.H. *Varieties of Imagination & Nothingness*
 In The Global Village
 Canadian Journal of Sociology,
 Vol. 28, No. 2, 235-244
 University of Toronto Press 2003

Siniscalchi, G.B. *A Response To Professor Krauss*
 On Nothing
 Heythrop Journal,
 Vol. 54, No. 4, 678-690
 Blackwell Publishing Ltd 2013

Slater, M. & Haufe, C.
 Where No Mind Has Gone Before:
 Exploring Laws in Distant
 & Lonely Worlds
 International Studies in Philosophy of
 Science,
 Vol.23, No.3, 265-276
 Carfax Publishing Co 2009

Smagorinsky, P. Et al
 Bullshit Academic Writing: A Protocol
 Analysis of A High School Senior's Process
 *Of Interpreting **Much Ado About Nothing***
 Research in The Teaching of English,
 Vol.44, No.4, 368-405
 National Council of Teachers of English
 Chicago 2010

Smee, S. *Cy Twombly & Nothingness*
 Prospect,
 Issue 96, March
 Prospect Publishing Ltd, London 2004

 How To Do Nothing:
 Lucien Freud's New Tate Exhibition
 Is Misunderstood As Portraiture.
 It Is About The Pleasure of Indolence.
 Prospect, Issue 76, July
 Prospect Publishing Ltd, London 2002

Smith, S. *Something For Nothing:*
 Late Larkins& Early
 English, Vol.49, Issue 195, 255-276
 Journal of The English Association 2000

Sohlberg, P. *Is There Nothing Beyond Postmodernism &*
 'The Theoretical Other'? The Need For
 Balancing Universalism & Diversity
 In Social Work
 International Journal of Social Welfare,
 Vol.18, No.3, 317-322
 Blackwell Publishing Ltd 2009

Solo, M., Canavan, G. & Wald, P.
 Nations of Nothing But Poetry:
 Modernity,Transnationalism, &Synthetic
 Vernacular Writing *by Mathew Hart*
 American Literature: A Journal of Literary
 History, Criticism & Bibliography,
 Vol.83, No.2, 451-453
 Duke University Press 2011

Sopcak, P. *'Creation From Nothing': A Foregrounding*
 *Study of James Joyce's Drafts For **Ulysses***
 Language & Literature: Journal of The
 Poetics & Linguistics Association,
 Vol.16, No.2, 183-196
 Longman 2007

Spangrude, G.J.
 What If Nothing Grows?
 Blood, Vol.102, Part 9, 3077
 American Society of Haematology 2003

Sparks, B. *Labour: Nothing Else Matters*
 American Fruit Grower, Vol.131, No.7, 34
 Meister Publishing Company2011

Specter, A. *The Power of Nothing - Do Placebos Work?*
 The New Yorker, 12th Dec., 30-37
 New Yorker Magazine Inc. 2012

Spiller, N. *Avatar: Nothing Is Impossible*
 Architectural Design,
 No.83, No.5, 50-55
 John Wiley & Sons Ltd 2013

Stanley, L. ***Nothing Mat(t)ers: A Feminist Critique***
 Of Postmodernism *by Somer Brodribb*
 Women's Studies International Forum
 Vol.17, No.2/3, 316
 Pergamon Press 1994

Stanley, L. & Salter, A.
 "Her Letters Cut Are Generally Nothing
 Of Interest": The Heterotopic Persona of
 Olive Schreiner & The Alterity-Persona of
 Cronwright-Schreiner
 English in Africa,
 Vol.36, No.2, 7-30
 Institue For The Study of English in Africa,
 Rhodes University 2009

Steirer, G. *The Other Who Does Nothing*
 Women & Performance,
 Vol.13, Pt 1, 159-68
 WP 2002

Stern, S. & Harding, D.
 Profits & Perils of Public Private
 Partnerships: Governments Around The
 World Are Increasingly Turning Towards
 Public Private Partnerships To Make
 Limited Budgets Go Further. But They Can
 Be Extremely Complicated, & Participants
 Should Take Nothing For Granted
 Euromoney, February, 126-31
 Euromoney Publications 2002

Stevens, Q. *Nothing More Than Feelings*
 Architectural Theory Review,
 Vol.14, No.2, 156-172
 Taylor & Francis Ltd 2009

Stevens, V. *Nothingness, No-Thing & Nothing*
 In The Work of Wilfred Bion &
 In Samuel Beckett's, **Murphy**
 The Psychoanalytic Review,
 Vol. 92, No. 4, 607-636
 National Psychological Association For
 Psychoanalysis 2005

Stillman, P.G. & Goodwin, B.
 'Nothing Is, But What Is Not': Utopias as
 Practical Political Philosophy
 Critical Review of International Social and
 Political Philosophy, Vol.3, No.2/3, 9-24
 Frank Cass 2000

Stowe, M. *Family Business: Nothing Prepares You For*
 The Death Of A Client
 The Solicitor's Journal, Vol.155, No.19, 7-16
 Wilmington Group Plc 2011

Sweeney, J.D. *Nothing To Offer But Blood*
 Medicine & Health, Vol.8, No.12, 383-384
 Rhode Island US 1998

Sweeney, M. *Point: Nothing Matters & What If It Did?*
 Heart Rhythm, Vol.9, No.7, 1157
 Elsevier Science B.V. Amsterdam 2012

Sweeney, P. *Without A Bank You're Nothing*
 U.S. Banker,
 Vol, 112, Part 4, 30-33
 Faulkner & Gray, Inc 2002

Syme, J. *Haul or Nothing For Mobile Operators*
 Electronics World, No. 1921, 14-16
 EW 2013

Takayama, A. *Without Ambition One Starts Nothing*
 Journal – Society of Automative Engineers
 Of Japan, Vol.64, Part 11, 108
 SAEJ 2010

Tarrant, J. *Nothing Soft About GIMP Software*
 British Journal of Photography,
 Issue 7489, 21-22
 Bouverie Pubishing Ltd 2004

Taussig, D. *Low-Paid, Liberal, Nonprofit Yuppies Unite:*
 You Have Nothing To Lose But Your Chains
 The Washington Monthly,
 Vol.39, No.10, 49-52
 Washington Monthly Company 2007

Taylor, C. *Nothing Left To Lose? Freedom &*
 Compulsion In The Treatment of
 Dangerous Offenders
 Psychodynamic Practice: Individuals,
 Groups & Organisations,
 Vol.17, No.3, 291-306
 Taylor & Francis Ltd 2011

Teachout, T. *Plenty of Nothing:*
 How The Composer
 John Cage Killed Musical Modernism
 Commentary, October 55-58
 American Jewish Committee 2010

Terresi, D. *Zero:*
 The Invention of A Number Denoting
 Nothingness Was A Signal Human
 Achievement,
 But It Has Also Accounted
 For Much Fussing Over Calendars
 The Atlantic, Vol. 280, No. 1, 88-94
 Neodata Servicers Group 1997

Textor, M. *'Intense Heat Immediately Perceived Is*
 Nothing Distinct From A Particular Sort
 Of Pain'
 British Journal For The History of
 Philosophy,
 Vol. 9, Part 1, 43-68
 Thoemmes Press, London 2001

Tezoquipa, I.H., Monreal, L.A. &Trevino-Siller, S.
"Without Money You're Nothing":
Poverty & Health in Mexico
From Women's Perspective
Revista Latinamericana de Enfermagem,
Vol.13, No.5, 626-33
RLDE 2005

Theoharis, T.C.
Making Much of Nothing
James Joyce Quarterly, Vol.33, 4, 583-592
University of Tulsa 1996

Theroux, P.
English Hours: Nothing Personal
Granta, Issue 114, 223-34
Granta Publications, London 2011

Tietjen, M.A.
Being Anxious For Nothing:
Heidegger & Kierkegaard on Anxiety
Dialogue, Vol. 47, Part 2/3, 67-68
PHI SIGMA TAU 2005

Tijsseling, A.
Do Features Arise Out Of Nothing?
The Behavioural & Brain Sciences,
Vol.21, No1, 38
Cambridge University Press 1998

Tozer, J. *Not Nothing*
Art Monthly, No. 214, 34-36
Brittania Art Publications 1998

Trevarthen, C.
What Is It Like To Be A Person Who Knows
Nothing? Defining The Active Intersubjective
Mind of A Newborn Human Being
Infant Child Development,
Vol.20, No.1, 119-135
John Wiley & Sons, Ltd 2011

Trivedi, P. 'Nothing About Us, Without Us' –
 A User/Survivor Perspective
 On Global Mental Health
 International Review of Psychiatry,
 Vol.26, No.5, 544-550
 Informal Healthcare 2014

Trussler, M. Pockets of Nothingness: 'Metaphyiscal
 Solitude' in Alice Munro's, **"Passion"**
 Narrative, Vol. 20, No. 2, 183-197
 Ohio State University Press, Columbus 2012

Vail, M. Nyle Steiner's Electronic Valve Instrument:
 Nothing To Spit At
 Keyboard, Vol.30 No.7 100
 Miller Freeman Publication 2004

Vance, E. Why Nothing Works: We've All Heard of
 The Placebo Effect, But How Many of Us
 Understand How It Really Works?
 New Research Suggests Even
 Doctors Have Been Getting It Wrong
 Discovery, Vol.35, No.6, 42
 Elsevier, Amsterdam 2014

Van Dyke, C. The Truth, The Whole Truth & Nothing But
 The Truth: Robert Grosseteste On Universals
 (& The Posterior Analysis)
 Journal of The History of Philosophy,
 Vol. 48, No. 2, 153-170
 The History of Philosophy, Inc 2010

Van Vliet, D. The Final Word: What To Do
 When There's Nothing More To Do
 Hearing Journal, Vol.50, No.4, 92
 Kluwer 1997

Veldstra, C. Laughing At Nothing: A Response To
 RyanWeber's, **"Ironically, We Dwell"**
 JAC – AMES,Vol.33, No.1/2, 325-335
 University of South Florida 2013

Wainer, H. *When Nothing Is Not Zero*
Chance, Vol.25, No.2, 49-51
Taylor & Francis Ltd 2012

Walden, P. *Less Than Nothing:* **Hegel & The Shadow**
Of Dialectical Materialism, *by Slavoj Zizek*
The Owl of Minerva, Vol.45, No.1/2 115-27
Hegel Society of America 2014

Walt, S. *Nothing Revolutionary*
Review of International Studies,
Vol. 27, Part 4, 687-92
Butterworths 2001

Wang, S. *Identity & Freedom in* **Being & Nothingness**
What Sartre Thought It Is To Be Human
Philosophy Now, Issue 64, 20-25
PN London 2007

Ward, C.D.
On Doing Nothing: Descriptions of Sleep,
Fatigue, & Motivation in Encephalitis
Lethargica
Movement Disorders, Vol.26, No.4, 599-604
John Wiley & Sons Ltd 2011

Ward, D.C.
Criticism Makes Nothing Happen
PN Review, Issue 161, 532-56
XL Publishing Services 2005

Ward, M.L.
The Internet: "A Tissue of Nothingness",
Says One Of Its Pioneers – In A Book
Logos: The Professional Journal For The
Book World, Vol. 6, No. 2, 84
Brill 1995

Watts, G. *All A-Twitter About Something... Or Nothing?*
Dancing Times, No 1219, 23-25
The Dancing Times Ltd, London 2012

Waugh, D. *Working For Nothing: A Tradition Continues*
 Canadian Medical Association Journal,
 Vol.155, No.1, 93-95
 CMA 1996

Weir, B. *'Degrees In Nothingness': Battlefield*
 Topography in The First World War
 The Critical Quarterly,
 Vol. 49, No. 4, 40-55
 Blackwell Publishing Ltd 2007

Weiss, P. *Seeking The Mother of All Matter:*
 World's Mightiest Particle Collider May
 Transform Less-than-Nothing Into
 A Primordial Something
 Science News,
 Vol.158, Part 9, 136-139
 Science News - Online 2000

Weller, S. *Nothing To Be Said:*
 On The Inexpressible
 In Modern Philosophy and Literature
 Angelika, Journal of The Theoretical
 Humanities, Vol. 8, Part 1, 91-108
 Carfax Publishing Ltd 2003

Wenger, R.M. *There Is Nothing More Powerful Than*
 Illusion
 Chimia: Chemie Report,
 Vol.54, Part 4, 241
 Helvetica Chimica Acta 2000

Wenning, M. *Kant & Daoism on Nothingness*
 Journal of Chinese Philosophy,
 Vol. 38, No. 4, 556-568
 Blackwell, Oxford 2011

Wenzel, C. *Kant Finds Nothing Ugly?*
 The British Journal of Aesthetics,
 Vol. 39, No.4, 416-422
 Oxford University Press 1999

Wermers, J.

Sex In The Wooden O: Exploring A Hetero v
Queer Matrix In The USF Production Of
**Much Ado About Nothing, The Merchant
Of Venice & Macbeth**
The Journal of The Wooden O Symposium,
Vol.10, 60-76
Southern Utah University Press 2010

West, R.L. *Are There Nothing But Texts In This Class?*
Interpreting The Interpretative Turns In
Legal Thought
Chicago-Kent Law Review, V.76, 2, 1125-68
Chicago 2000

Westover, J.

Nations of Nothing But Poetry:
Modernity, Transnationalism & Synthetic
Vernacular Writing, by *Mathew Hart*
Style, Vol.47, No.1, 123-126
Northern Illinois University 2013

White, B. *Assuming Nothing: A Pre-Methods*
Diagnostic in The Teaching of Literature
English Education, Vol.27, No.4, 221-239
ED 1995

White, J. *The Secular & The Religious:*
Is There Nothing Between Them?
A Reply To Yong-Seok Seo
Journal of Philosophy of Education:
The Journal of The Philosophy of Education
Society, Vol. 48, No. 4, 533-538
Blackwell Publishing Ltd 2014

Wigan, M. *Don't Farm, Play Golf. An EU Review*
Could See Farmers Paid To Do Nothing,
With Dramatic Results
The Field,
Issue 7 No. 187 92-94
IPC Magazines Ltd 2003

Wiley, S. *Collaborations:*
Challenging But Key Like Any Relationship,
Collaborations Take Energy
But Nothing Is Better For Your Research
The Scientist, Vol. 23, No. 10, 20-29
The Scientist, Inc 2009

Wilkowski, J.A. *"Nothing To Laugh At At All":*
Humour in Biochemical Journals
Trends in Biochemical Science,
Vol.21, No.4, 156-159
TBS 1996

Williams, J. *Nothing Like Maudlin (Jean-Francois*
Lyotard)
The Journal of The British Society for
Phenomenology, Vol. 32, Part 3, 312-27
JBSP 2001

Williams, P. *Look At It This Way – It's Nothing Personal*
Therapist, Vol.5, No.4, 9-11
European Therapy Studies Institute 1998

Williams, R. *Nothing To Find: Verhoeven's,* **Showgirls**
Echoes Busby Berkeley and The Erotic
Video Tradition
Sight & Sound, Vol.6 No.1 28-30
British Film Institute, London 1996

Williams, S.E. *"Nothing Happens Unless First A Dream"*
(Part 1).The First Steps in Applying
LastingPurpose Principles Are Building
An Abundance of Love & Adopting
A LovingMindset
Today's Chiropractic, Vol.29, Part 5, 6-11
1269 Barclay Circle, Marietta GA 2000

Winkler, R. *Nietzsche and The Circle of Nothing:*
The Turns and Returns of Fetishism
Philosophy Today, Vol.51, No.4, 427-37
De Paul University 2007

Wippel, J.F.
> *Thomas Aquinas on The Ultimate Why*
> *Question: Why Is There Anything At All*
> *Rather Than Nothing Whatsoever?*
> Studies in Philosophy& The History of
> Philosophy, Vol. 54, 84-108
> Catholic University of America 2011

Wirth, J.M.
> *Exhilarated Despair and Optimism in*
> *Nothing: Francis Bacon & The Question*
> *Of Representation*
> International Studies in Philosophy,
> Vol.31, No1, 123-138
> State University of New York 1999

Witt, M.T.
> *Memeing Versus Nothingness:*
> *When Less Is... Important*
> Public Performance & Management Review,
> Vol. 27, Part 3, 134-138
> Sage Publications 2004

Wohlfart, G.
> *Heidegger & Laozi: Wu (Nothing) On Chapter*
> *11 Of **The Dao Dejing**, Trans. M. Heitz*
> Journal of Chinese Philosophy, 30, 1, 39-60
> Blackwell, Oxford 2003

Wolf-Devine, C. & Alston, W.P.
> *Countering The 'Nothing But' Argument*
> Faith & Philosophy: Journal of The Society
> Of Christian Philosophers, Vol. 4, 482-95
> The University of Notre Dame 2005

Wolfson, E.R.
> *Nihilating Nonground & The Temporal Sway*
> *Of Becoming: Kabbalistically Envisioning*
> *Nothing Beyond Nothing*
> Angelaki: Journal of The Theoretical
> Humanities, Vol. 17, No. 3, 31-45
> Taylor & Francis 2012

Woody, E. & Sadler, P.
 The Rhetoric & Science of 'Nothing But'
 Contemporary Hypnosis,
 Vol.15, No.3, 171-81
 Whurr Publishers UK 1998

Worstell, J.H.
 Something For Nothing – Improving Fixed
 Bed Catalytic Reactor Performance Without
 Capital Expenditure
 Process Improvement in Manufacturing –
 New Orleans, LA,
 O, 87-124, March 2002
 AICHE 2002

Wright, G.
 The Riddle of The Sands: Deep In The
 Sahara Lie Vast Deposits of Incredibly Pure
 Glass That Nothing On Earth Could Have
 Created
 New Scientist, No.2194, 42-45
 IPC Magazines Ltd 1999

Wright, S.
 There Is Nothing Soft About Spirituality
 Nursing Standard: The Official Bulletin of
 The Royal College of Nursing & National
 Council of Nurses of The UK,
 Vol.21, No.19, 26
 RCN Publishing 2007

Wright, T.J.
 Creation Out of Nothing:
 A Biblical, Philosophical
 & Scientific Exploration,
 By Paul Cogan & William Lane Craig
 Heythrop Journal, Vol. 52, No. 2, 311-312
 Blackwell Publishing Ltd 2011

Xiuchun, H. Et al
 Application Of Silicon On Nothing Structure
 For Developing A Novel Capacitative
 Absolute Pressure Sensor
 IEEE Sensors Journal,
 Vol.14, No. 3, 808-15
 IEEE 2014

Yeoh, G. *J.M. Coetzee & Samuel Beckett:*
Nothingness, Minimalism & Indeterminacy
Ariel: A Review of International Literature,
Vol. 31, Part 4, 117-137
University of Calgary Press, Alberta 2000

Young, P. *In Conversation: Nothing NewAbout Ageism*
Elderly Care, Vol.6, No.6, 45
RCN Publishing Ltd 1994

Younge, G. *Much Ado About Nothing – An Empty*
Plinth in London Sparks A Public Debate,
Art Papers Magazine, Vol. 27, Part 1 16-21
Atlantic Art Papers Inc, 2013

Zaborowski, H.
Why Is There Anything At All Rather Than
Absolutely Nothing? F.W.J. Schelling's
Answer To The Ultimate Why Question
Studies in Philosophy & The History of
Philosophy, Vol.54, 146-169
Catholic University of America Press 2011

Zarpentine, C.
Nothing Makes Sense Except in Light of
Evolution
Metascience, Vol.22, No. 2343, 43-46
Springer Science & Business Media 2013

Zhang, E.Y.
Weapons Are Nothing But Ominous
Instruments:
The Daodejing's *View On War & Peace*
Journal of Religious Ethics, 40, 3, 473-502
Blackwell Publishing Ltd 2012

Zheng, Y. *Ontology & Ethics in Sartre's,*
Being & Nothingness:
On Conditions of Possibilityof Bad Faith
The Southern Journal of Philosophy,
Vol. 35, No. 2, 265-287
Memphis State University 1997

Zicaarelli, D. *How I Learned To Love A Programme That Does Nothing*
Computer Music Journal,Vol. 26 Pt 4, 44-51
Massachusetts Institute of Technology 2002

Abrams, E *Image Is Everything, Image is Nothing: A Reflection on/of(f) Tessa Adams' Paper*
European Journal of Psychotherapy, Counselling & Health,
Vol.6, No.4, 327-31
Brunner, Routledge 2003

Ackerman, D. *Nothing May Be More Important To A Baby Than Physical Contact*
American Health, Vol.12, No.8, 70
Communications Data Services 1993

Adams, F.C. & Laughlin, G.
Embracing The End:
The Vast Future Holds Remnants of Dead Stars In Collision, Decay of Particles & Eternal Nothingness
Astronomy, Vol. 28, Part 10, 48-53
Kalmbach Publishing Co 2000

Afriat, A. Et al *Can Nothing Cause Nonlocal Quantum Jumps?*
AIP Conference Proceedings,
Vol.844, 3-7
IOP Institute of Physics Publishing Ltd 2006

Aila, M. *"Nothing But The Dust" – A Philosophical Approach To The Problem of Identity and Anonymity in Samuel Beckett's, **Trilogy***
Philosophical Forum,
Vol.40, 127-147
Blackwell Publishing Ltd 2009

Akira, A. *In The Place of Nothingness*
New Left Review, Issue 5, 15-40
NLR Ltd 2000

Alexander, J.
 It's Nothing Personal, It's Just Business:
 Economic Instability & Distribution of Harm
 Business Ethics Quarterly, Vol.10, 3, 545-62
 JOSBE 2000

Alford, M. **How To Get Something From Nothing:**
 A Universe from Nothing, by L. M. Krauss
 The Skeptical Inquirer, Vol. 36, No. 6, 54-55
 Committee For SI, Amherst, New York 2012

Almog, J. *Nothing, Something, Infinity*
 The Journal of Philosophy, V. 96, 9, 462-78
 TJOP 1999

Anon *Being & Nothingness: Jonathan Griffin Talks*
 To Bill Viola About His 40-Year Career
 & Upcoming Retrospective At
 The Grand Palais, Paris
 Apollo: The International Magazine of Art
 & Antiques, No. 618, 122-129
 AM Ltd 2014

Anon *BIG BANG TO BIG BOUNCE: What If Our*
 Universe Didn't Appear From Nothing, But
 Was Recycled From One That Went Before?
 New Scientist, No.2686, 32-35
 IPC Magazines Ltd 2008

Anon *Burnout In Mental Health Nurses:*
 Much Ado About Nothing?
 Stress Medicine,
 Vol.15, No.2, 127-134
 John Wiley & Sons Ltd 1999

Anon *CUTTING IT SHORT.*
 There's Nothing Worse Than Painful
 Toenails When You're Dancing On Points.
 Here's How To Look After Them
 Dance Australia, Issue 154, 62-63
 YAFTA Publishing Group Pty Ltd 2008

261

Anon *Dark Ghosts: Cosmos Made of Nothing*
<u>New Scientist</u>, No.2958, 12
IPC Magazines 2014

Anon *Designer Soups:*
Nothing Warms Cold Bones On A Snowy Day
Like A Steaming Bowl Of Soup
<u>Food Product Design</u>, Vol.9, No.8, 116-40
Weeks Publishing Co 1999

Anon *Droog Straps: Looking At Your Empty Wall,*
You May See It Is So Boring That There
Is Nothing There. How About Making
Your Wall To Hold Your Books,
Clothes Or Beautiful Flowers?
<u>Rubber India</u>, Vol.64, NO.5, 91
AZKO Chemicals BV 2012

Anon *Feeding Japanese Cows: The UK May Have*
Occasional Feed Problems, But They Are
Nothing Compared To Japan's Constant
Lack of Forage
<u>Dairy Farmer</u>, Vol.44, No.1, 24-25
United News & Media Publication 1997

Anon *Has Africa Contributed Nothing To The*
World of Science?
<u>Courier: African Caribbean Pacific European</u>
<u>Union</u>, Issue 157, 56-58
Steffen Smidt-E.C. 1996

Anon *Idle Minds: The Brain Is Surprisingly Active*
– Even When Its Doing Nothing
<u>Nature</u>, Vol. 489, No.7416, 356
Nature Publishing Group 2012

Anon *In Brief: Male Fertility Is In The Bones.*
Neanderthals Played Dress-up.
Bad Taste Affects Moral Judgement.
Molecules Bounce Off "Nothing"
<u>New Scientist</u>, No. 2801, 15-20
IPC Magazines 2011

Anon *Insurance: Nothing To Lose*
<u>Waste Age</u>, Vol.35, Part 9, 36
WA Magazine 2004

Anon *Internet: Much Ado About Nothing*
<u>Communications International</u>,
Vol.24, No.1, 22-24
Emap Business Publications 1997

Anon *Leaving Nothing To Chance*
<u>Flight International</u>,
No.5411, 28
Reed Business Publishing 2013

Anon *Man Ticketed 170 Times For "Nothing"*
<u>Accident Reconstruction Journal</u>,
Vol.19, No.4, Issue 112, 7
ARJ 2009

Anon *Manzoni: Being & Nothingness*
Barry Barker On Manzoni As Myth-Maker
<u>Art Monthly</u>, Issue 215, 1-6
Brittania Art Publications 1998

Anon *Much Ado About Nothing*
<u>Acta Ophthalmologica</u>,
Vol.86, Supp/243
Blackwell Publishing Ltd 2008

Anon *Nothing Fragile In This*
<u>American Shipper</u>,
Vol.35, No.5, 44
Howard Publications Ltd 1993

Anon *Nothing If Not Predictable*
<u>Virus Bulletin</u>, February, 3
VB Ltd UK 200

Anon *Nothing In Common:*
All Numbers AreMade Of It
<u>New Scientist</u>, No.2839, 44-45
IPC Magazines Ltd 2011

Anon *Nothing Is Forgotten In The State of*
Denmark
Machinery & Production Engineering,
Vol.155, No.3942, 9
Findlay Publications 1997

Anon *Nothing Is Green Without Water*
Plumbing Engineer, Vol.37, No.5, 16
TMB Publishing Inc 2009

Anon *Nothing Is Impossible If It Has Happened*
Before
Engineering & Mining Journal,
Vol. 199, No.3, 13
Maclean Hunter Publishing Co 1998

Anon *Nothing Less Than Literal:*
ArchitectureAfter Minimalism
Journal of Architectural Education,
Vol.59, No.4, 83-84
Elsevier Science B.V. Amsterdam 2006

Anon *'Nothing's Quite The Same Without Fans...* '
South African Mechanical Engineer,
Vol.52, Part 6, 19-20
Mattec Publishing 2002

Anon *Nothing Says Healthy Living Like A Breath*
Of Fresh Air:
Welders Can Adequately Prevent Health
Hazards By Knowing The Risks Associated
With Different Types of Welding Fumes
The Fabricator, Vol.35, No.8, 42-5
The Croydon Group 2005

Anon *Nothing To Sneeze At: Rethinking Allergies*
New Scientist, No2894, 30
IPC Magazines ltd 2011

Anon *Nothing Works Better Than Tools*
Software Management, Issue 36, 12
Process Communications Ltd 1993

Anon *Our Forgotten Years: We Remember Next to
Nothing From The Time Before We Go To
School. Why Is That?*
New Scientist,
No.2810, 42-45
IPC Magazines Ltd 2011

Anon *Our Search For Earth-like Planets Has
Failed To Take One Detail Into Account -
They Might Look Like Nothing On Earth:
Planet Hunters Need A Whole New Tool Kit*
New Scientist, No 2403, 28-31
IPC Magazines Ltd 2003

Anon *Paradox of Nothing: There's A Lot To It*
New Scientist, No2847, 46-47
IPC Magazines Ltd 2012

Anon *Physics & Philosophy: Being & Nothingness*
The Economist, No. 8639, 82
Economist Newspaper Ltd 2009

Anon *Running On Empty:
What's Behind NASA's Idea To Send A
Spaceship Beyond The Solar System?
Nothing At All.*
New Scientist, No.2131, 36-37
IPC Magazines Ltd 1998

Anon *Samuel Beckett Laughter Behind The
Nothingness*
The Economist, No. 8489, 90
The Economist Newspaper Ltd 2006

Anon *Something From Nothing:
Packaging Design Brings Together
The Best of Right-Brain Creativity
With Left-Brain Logic*
Package Printing: For Printers & Converters
Of Labels, Flexible Packaging & Folding
Cartons, Vol.55, No.2, 38-45
PP Philadelphia 2008

Anon *The Amateur Scientist:*
Fun With A Jar Full Of Nothing
Scientific American,
Vol.275, No.5, 114-15
CDS Communications Data Services 1996

Anon *The Case For Transparency: As Its*
Discussion in Bangalore Proved, The
Industry Has Nothing To Fear From
Openness
Tobacco Reporter, Vol.138, No.1, 18-21
Speccom International Inc 2011

Anon THE POWER OF NOTHING. With The
Right Encouragement Your Mind Can
Convince The Body To Heal Itself.
What's The Mysterious Force Involved?
New Scientist, No.2292, 34-37
IPC Magazines Ltd 2001

Anon *There Is Nothing As Diverse As A Nurse*
The Lamp,
Vol.57, Part 6, 15
NSW Nurses Association 2000

Anon *There's Nothing Like Being There*
Control Engineering, Vol.44, No.2, 57
Canners Publishing 1997

Anon *There's Nothing Strange About Individual*
Fundamentalists: It's When They Get
Together That Things Start To Happen
New Scientist, No. 2520, 44-46
IPC Magazines Ltd 2005

Anon *The World's Greatest Entrepreneurs:*
These 11 Superstars Triumphed Over Ailing
Ailing Economies, Oppressive Governments,
& Uncertain Future To Build Prosperity
Out Of Nothing
Success – New York, Vol.43, No.5, 34-58,
Lang Communications 1996

Anon *Trust Nothing: On Our Self-Deceiving Ways*
 New Scientist, No.2837, 47
 IPC Magazines Ltd 2011

Anon *Washington Watch:*
 Agreeing To Disagree On Nothing
 Aerospace America, Vol.50, No.5, 10-13
 American Institute of Aeronautics &
 Astronauts 2013

Anon *Waste Nothing*
 AT Mineral Processing – Europe,
 Jahr 55, No.9, 20-21
 Bauverlag BV GMBH 2014

Anon *Web Fight:*
 Nothing Else To Bet On? Try Spiders
 Far Eastern Economic Review,
 Vol.166, Part 48, 55
 Review Publishing Co Ltd 2003

Anon *"Words That Convey Nothing"*
 Fire Engineering, Vol.149, No.3, 198
 FE, University of Ulster 1996

Anon *"You Are Chemistry":*
 All of Life Nothing But Chemistry?
 Chromatographia, Vol.51, Part 7/8, 384
 F. Vieweg & Sohn Verlagsgesellschaft 2000

Anon *Zero, Zilch & Zip: Cynics Have Long*
 Suspected That Nothing Lies At The Heart
 Of Maths. How Right Are They?
 New Scientist, No.2131, 40-44
 IPC Magazines Ltd 1998

Anselmi, N. Et al
 Obsessive Neurosis:
 The Self Between Being & Nothingness
 Rivista Di Psichiatria, Vol. 40, 5, 307-09
 Il Pensiero Scientifico Editore 2005

Aranyos, I. *Talking AboutNothing: Numbers,*
 Hallucinations & Fictions, by J. Azzouni
 Philosophy, Vol. 87, No1, 145-50
 Cambridge University Press 2012

Archdeacon, A. *The "Nothing" Trope:*
 Self-Worth in Renaissance Poetry
 Literature Compass,
 Vol.11, Issue 8, 549
 John Wiley & Sons Inc 2014

Aronson, S.M. & Hopkins, R.A.
 There Is Nothing Like A Redhead!
 Medicine & Health,
 Vol.89, No.1, 5
 Rhode Island 2006

Ashkan, K. *Nothing Is Impossible*
 Britsh Medical Journal,
 No.7561, Supp 46-47
 BMA, London 2006

Ashmore, R. *"Suddenly There Was Nothing":*
 Foot & Mouth, Communal Trauma
 & Landscape Photography
 Photographies,
 Vol.6, No.2, 289-306
 Taylor & Francis UK 2013

Atayurt, Z.Z. *"It Has Nothing To Do With Hunger":*
 Reading Excess As A Public Text in
 The FatWoman's Joke
 Contemporary Women's Writing,
 Vol.5, No.2, 125-142
 Oxford University Press 2011

Avery, D. & Sayers, J.V.
 Nothingness, Politics & Psychoanalysis:
 Simone Weil & Marion Milner
 Psychoanalytic Studies, Vol. 3, N. 2, 209-222
 Carfax 2001

Avila-Saavedra, G.

> *Nothing Queer About Queer Television:*
> *Televised Construction of Gay Masculinities*
> Media, Culture & Society,
> Vol.31, No.1, 5-22
> Sage Publications 2009

Avison, M, J.

> *Functional Brain Mapping:*
> *What's It Good For? Absolutely Nothing?*
> *(Comments on **The New Phrenology***
> *By W.R. Uttal)*
> Brain & Mind, Vol.3, No.3, 367-73
> Kulwer Academic Publishers 2002

Baek, J. *From The Topos of "Nothingness" To*
> *The "Space of Transparency":*
> *Kitaro Nishida's Notion of Shintai*
> *& His Influence on Art & Architecture*
> Philosophy East & West,
> V. 58, No. 1, 83-107
> University of Hawaii Press, Honolulu 2008

Bahn, P.G., Bednarik, R.G. & Steinbring, J.
> *Hear Nothing, See Nothing, Say Nothing?*
> Rock Art Research: The Journal of The
> Australian Rock Art Association (AURA),
> Vol.14, No.1, 55-57
> Archaeological Publications 1997

Bai, T. *An Ontological Interpretation*
> *Of You (Something) (?) & Wu (Nothing) (?)*
> *In **The Laozi***
> Journal Of Chinese Philosophy,
> Vol. 35, No.2, 339-351
> Blackwell Publishing Ltd 2008

Baicus, C. *A Study That Shows Nothing*
> European Archives of Psychiatry &
> Clinical Neuroscience
> Vol.262, No.8, 725
> Springer Science & Business Media 2012

Bailey, S. *Between Reality & Nothingness:*
George Lazongas
Art Paper Magazine,Vol. 33, No. 5, 22-26
Atlanta Art Papers Inc, 2009

Baillie, J. *The Expectation of Nothingness*
Philosophical Studies,
Vol. 166, No. 1, Supp/1, 185-203
Springer, Berlin 2013

Baldwin, T. *'There Might Be Nothing'*,
Analysis, Vol. 56, No4, 231-38
Oxford University Press 1996

Bang, J. *Nothingness & The Human Umwelt*
Integrative Psychological & Behavioural
Science,
Vol. 43, No. 4, 374-392
Springer 2009

Banks, I. *The Man Who Knows Everything Can Learn*
Nothing
Men's Health Journal: For Health
Professionals in Primary Care;
Vol.2, Part 2, 37f
Medical Education Partnership 2003

Barbone, S. *Nothingness & Sartre's Fundamentalist*
Project
Philosophy Today, Vol. 38, No. 2, 191
De Paul University, Chicago 1994

Barbour, J. *Timeless: Surely Nothing Is Possible*
Without Time
New Scientist, Issue 2208, 28-39
IPC Magazines Ltd 1999

Barrow-Green, J.

 Robert Kaplan: ***The Nothing That Is:***
A Natural History of Zero
Isis, Vol. 92, Part 3, 582-583
The University of Chicago Press 2001

Baum, D. *Groupware: Is It Notes or Nothing?*
 Datamation, Vol.41, No.8, 45
 Cahner's Publishing 1995

Baviera, I. ***Intern Nation: How To Earn Nothing &***
 Learn Little in The Brave New Economy,
 By Ross Perlin
 Labour History, Vol.53, 154-156
 Taylor & Francis 2012

Bayless, H.
 Think Nothing of It
 Studio Potter, Vol.35 No.2, 23-27
 Northampton MA 2007

Beaulieu, D.
 There's Nothing Like The Human Touch
 PC FAB, Vol.26, Part 1, 17
 CMP Media 2003

Beck, V. *Testing A Model To Predict Online Cheating*
 – Much Ado About Nothing
 Active Learning in Higher Education,
 Vol.15, Issue 1, 65
 Sage Publications 2014

Begam, R. *How To Do Nothing With Words, Or*
 Waiting For Godot *as Performativity*
 Modern Drama, Vol.50, No. 2, 138-167
 University of Toronto Press, 2007

Begian, H. *Nothing Can Match The Wonderful*
 Sound of a Full Concert Band
 Instrumentalist, Vol. 57 Part 5, 12-15
 Instrumentalist Company, 2002

Begley, A. *The Truth, The Hole Truth & Nothing*
 But The Truth:
 A Whistle-Stop Guide
 To The History of Rock Drilling
 Explosives Engineering, September, 8-11
 Straightline Publishing Ltd 1996

Behan, T. *'Nothing Can Be The Same Again'*
 International Socialism, Issue 92, 3-26,
 IS UK 2001

Bell, P.C. *Management Science: There's Nothing*
 Dismal About This Science
 Ivey Business Journal, Vol.63, No.4, 20-24
 Richard Ivey School of Business 1999

Benaroia, I. *Nothing To Cluck About*
 Foodservice & Hospitality,
 Vol.42, No.6, 10-14
 Kostuch Publications Ltd, Tortonto 2009

Bennett, M.V. *Sartre's, "The Wall"*
 &Beckett's, Waiting For Godot:
 Existential & Non-Existential Nothingness
 Notes On Contemporary Literature,
 Vol. 41, No. 4, 4-5,
 West Georgia College, Carrollton 2011

Beres, S. ***Bohin Manor:***
 Romance With Nothingness
 The Review of Contemporary Fiction,
 Vol. 14, No. 3, 189
 RCF 1994

Berke, J.H & Schneider, S.
 Nothingness & Narcissism
 Mental Health, Religion & Culture,
 Vol. 10, No. 4, 335-351
 Taylor & Francis UK 2007

Bernard, N. *INSIGHT:*
 Done Right, Satire Is Effectively Funny;
 Done Wrong, It Is Nothing ToLaugh About
 Step Inside Design, Vol. 18 Part 5 30-43
 SID 2002

Berruti, M. *H.P. Lovecraft & The Anatomy of*
 Nothingness: The Cthulhu Mythos
 Semiotica, Vol. 150, Issue 1-4, 563-418
 Walter de Gruyter & Co 2004

Betsky, A. *Almost Nothing:*
Life in The Bubble
DB: Deutsche Bauzeitung,
Jahr 241, No.3, 12-13
GMBH & Co KG 2007

Betts, T. & Greenhill, L.
The Cost of Everything & The Value of
Nothing
Seizure,
Vol. 10, Part 8, 628-632
W.B. Saunders & Co. Philadelphia 2001

Biddle, I. *Nothing Went Bang!*
Explosives Engineering, September, 21-24
Straightline Publishing Ltd 2002

Bilimoria, P.
Why Is There Nothing Rather Than
Something?
Sophia,
Vol.51, No.4, 509-530
Springer Science Business Media 2012

Bing, S. *The Spirit is Willing: I Felt an Emptiness So*
I Tried Buddhism. It Didn't Really Work.
You Have To Sit For Hours And Think Of
Nothing. I Normally Get Paid For That.
Fortune, Vol. 136, No.9, 31-37
Time Inc 1997

Birtwistle, T.
Academic Freedom & Complacency: The
Possible Effects If "Good Men Do Nothing"
Education & The Law, Vol.16, No.4, 203-16
Longman, Harlow UK 2004

Bisagni, F.
Out of Nothingness:
Rhythm & The Making of Words
Journal of Analytical Psychology,
Vol. 55, No. 2, 254-272
Blackwell Publishing, Oxford Ltd 2010